WESTERN UNION

ANGLO-AMERICAN DIRECT UNITED STATES
CABLEGRAM

NEWCOMB CARLTON, PRESIDENT

GEORGE W. E. ATKINS, VICE-PRESIDENT BELVIDERE BROOKS, VICE-PRESIDENT

Received at 16 BROAD STREET, NEW YORK

A 18/31K D

YENIKEUY 50

JACOB SCHIFF

NEWYORK

PALESTINIAN JEWS FACING TERRIBLE CRISIS BELLIGERENT COUNTRIES STOPPING

THEIR ASSISTANCE SERIOUS DESTRUCTION THREATENS THRIVING COLONIES FIFTY

THOUSAND DOLLARS NEEDED BY RESPONSIBLE COMMITTEE DR RUPPIN CHAIRMAN

TO ESTABLISH LOAN INSTITUTE AND SUPPORT FAMILIES WHOSE BREADWINNERS

HAVE ENTEROD ARMY CONDITIONS CERTAINLY JUSTIFY AMERICAN HELP WILL YOU

UNDERTAKE MATTER

MORGENTHAU

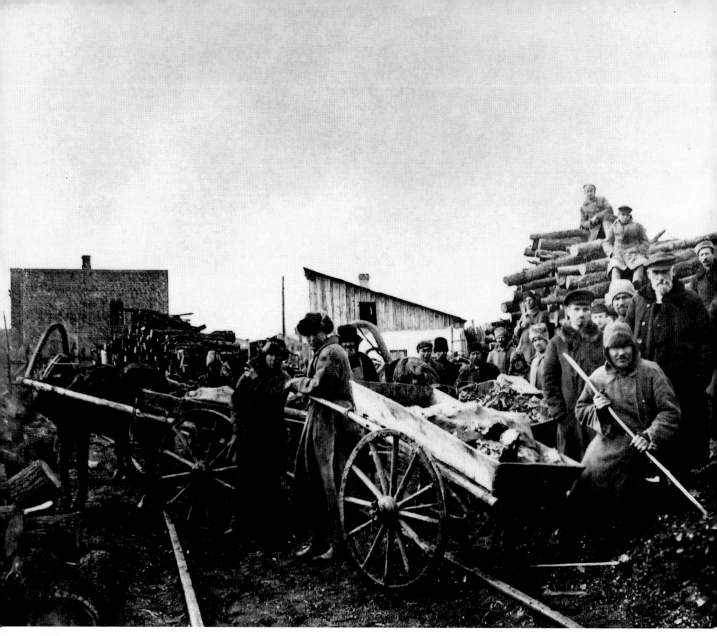

1914 In the midst of World War I the Jews in Palestine are starving and threatened with persecution by Turkish rulers. In August Henry S. Morgenthau, Sr., U.S. Ambassador to Turkey, cables Jacob H. Schiff in New York and requests $50,000 in aid. The money is raised, and on November 27 two newly established organizations, the (Orthodox) Central Committee for the Relief of Jews Suffering Through the War and the American Jewish Relief Committee unite under the chairmanship of Felix Warburg to form the Joint Distribution Committee.

(Overleaf) Telegram requesting help from Henry S. Morgenthau, Sr., to Jacob H. Schiff for the relief of Jews in Palestine. *(Above)* Distributing coal and wool to Jews. JDC relief and construction program following World War I, Kharkov, Soviet Russia, 1919.

TO THE RESCUE

Eight Artists in an Archive

Magdalena Abakanowicz
Alan Berliner
Wendy Ewald
Leon Golub
Pepón Osorio
Gilles Peress
Fred Wilson
Terry Winters

MARVIN HEIFERMAN and **CAROLE KISMARIC** Curators

BOYM DESIGN STUDIO Exhibition Design

EDWARD LEFFINGWELL Project Coordinator

Organized by **Lookout** for the **American Jewish Joint Distribution Committee**

TO THE RESCUE was made possible by a grant from the Estate of Emil Lang. Additional funding was provided by the Andy Warhol Foundation for the Visual Arts and the Friends of the JDC: Andrea and Charles Bronfman, The Samuel Bronfman Foundation, Judy and Nick Bunzl, Rita and Fred Richman, Elizabeth and Michael Varet, Marshall M. Weinberg, and Jane and Stuart Weitzman.

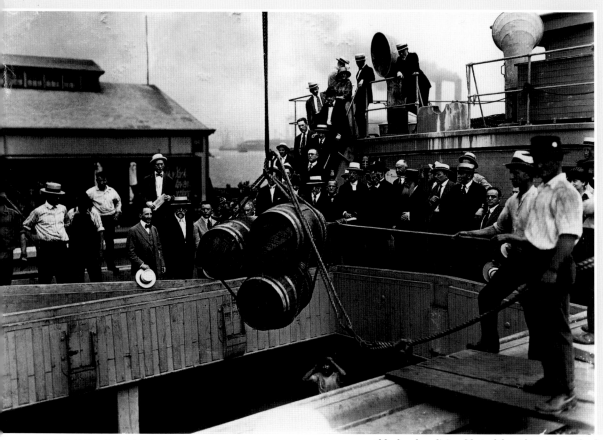

1915 The People's Relief Committee, which consists of labor and socialist groups, joins the JDC.
The USS *Vulcan* sails from New York to Palestine with 900 tons of food and medicine. Most of the aid is given to the Jews and the rest is distributed on a nonsectarian basis.

New York rabbis bless the first shipment of kosher meat to Poland, part of $8,000,000 worth of relief supplies sent to Eastern Europe by the JDC in 1919.

7 Director's **PREFACE**

11 Curators' **INTRODUCTION**

14 Magdalena **ABAKANOWICZ**

24 Alan **BERLINER**

34 Wendy **EWALD**

44 Leon **GOLUB**

54 Pepón **OSORIO**

64 Gilles **PERESS**

74 Fred **WILSON**

84 Terry **WINTERS**

95 **ACKNOWLEDGMENTS**

96 **PHOTO CREDITS**

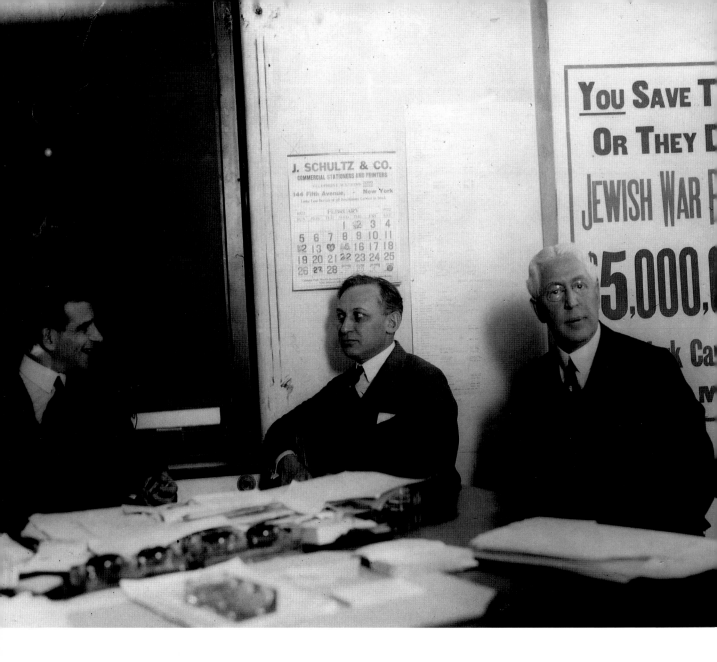

Campaign officials for JDC war relief: (l-r) David Bressler, David A. Brown, unidentified man. New York City, 1920s.

PREFACE

Why is the American Jewish Joint Distribution Committee presenting an exhibition of contemporary art? What is the connection between our humanitarian work and the visions of eight artists? As we approach the millennium *To the Rescue* is an opportunity to reflect on the contribution by the American Jewish community in shaping the history of our people, and how that work might inspire others.

The JDC was founded in 1914 when we sent aid to starving Jews in Palestine during the first World War. We have responded to the shocks and, at times, triumphs of geopolitical events in every decade since. The JDC rescued Jews from the Holocaust, cared for survivors in displaced persons camps, and ran past the British blockade and smuggled Jews to Palestine. We helped to rebuild Western Europe and continue to care for survivors in Eastern Europe. We sent packages to Refuseniks and today provide relief for 175,000 Jews in the former Soviet Union. We are helping Israel to create innovative solutions to solve its social service challenges. And in the past ten years we have rescued people from Iran, Yemen, Syria, Bosnia, Albania, and Ethiopia, to name only a few.

All these activities have been carried out to fulfill a mission encapsulated in three simple words: Rescue. Relief. Reconstruction. These words have inspired us during the past eighty-five years, yet there were times when the JDC was unable to publicize its activities for fear of endangering the communities we served. Circumstances have changed, and it is time to let the public know how our community has affected global Jewish life.

There is another reason why this exhibition of contemporary art needs to take place. We have seen American life altered by the distractions of affluence. A generation of young people has never experienced poverty or oppression. They live in a different, emancipated world, one of comfort, status, and luxury. Many are indifferent to what is going on outside the United States. The organizers of this exhibition feel that through the impact of art the commitment and involvement of their parents and grandparents in worldwide humanitarian affairs can be better appreciated.

Eight outstanding artists immersed themselves in the JDC's archives and created works of art inspired by their experience. People will see what has moved these artists, who have taken time to become involved with the achievements of American Jewish philanthropy. Through their art they help us understand the problems of the refugee, the hungry, the disadvantaged, the abused children, and the forgotten elderly.

But why visual art? Visual art is important because to many it represents a profound, deeply emotional reaction to the issues human beings face. This is particularly so for the artists in this show. Their visions and our photographs complement one another; each loses something without the other. Their works are an interaction between history and imagination, and just as the artists have been touched by our work, we are ready to be touched by them. The relationship between the artists and the archive is an inspired one that we hope the audience viewing *To the Rescue* will become a part of too.

—Michael Schneider, Executive Vice-President

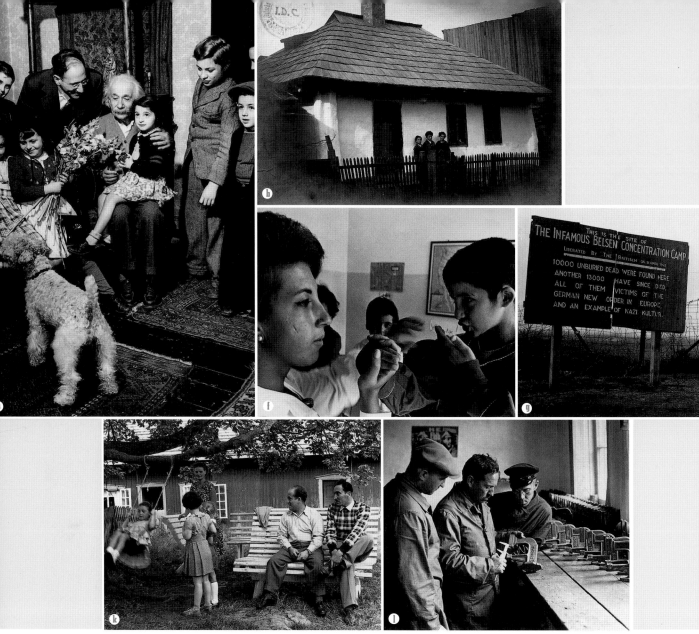

1917 America enters the war and transferring money to areas under enemy control becomes a problem. From its inception the JDC had cooperated with the state department in accomplishing its work, and now, with government approval, it sets up a committee in neutral Holland to aid people in war-stricken areas. Between the spring of 1917 and March 1918 the JDC channels close to $2 million into German-occupied territories.

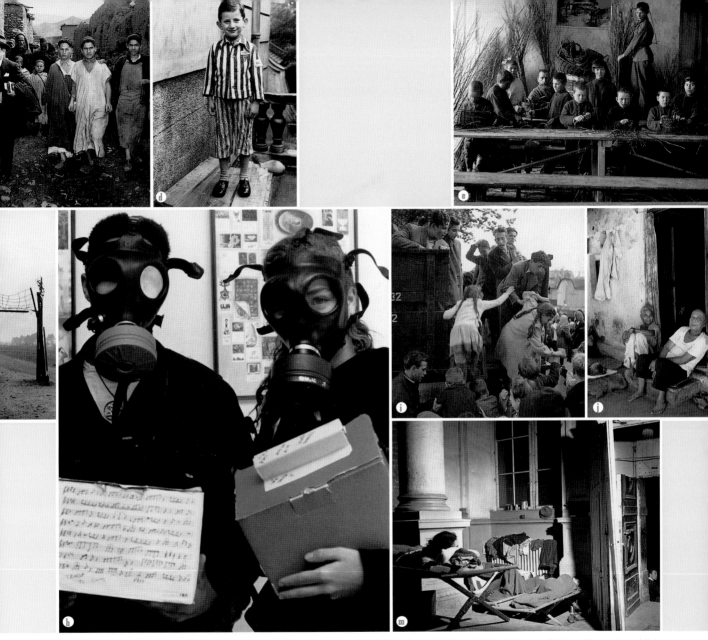

1918 Armistice Day, November 11, finds more than one million European Jews homeless. Pogroms and epidemics spread.

1919 Between 1919 and 1921 JDC raises $33.4 million and establishes soup kitchens and orphanages, reconstructs hospitals, and sends food to hundreds of towns and villages in Poland. To avoid arousing anti-Semitism much of the money is spent on nonsectarian missions.

Blumenfeld Circus. Germany, 1940s. j India, 1980s. k Jewish refugees recovering from TB at a transport center in Norway, 1953. Norway was the only country to admit TB and post-TB cases. l Agro-Joint factory workers, former Soviet Union, c. 1930. m A Romanian refugee in a Vienna hospital, 1947. An influx of nearly 4,500 displaced persons from Romania required the hospital, with a capacity for 350, to utilize hallways, cellars, and courtyards to provide for the refugees.

INTRODUCTION

The American Jewish Joint Distribution Committee, a humanitarian organization known as the JDC in the United States and as the Joint overseas, has since 1914 worked hard and imaginatively to fulfill its mission to bring relief, rescue, and rehabilitation to people caught up in the maelstrom of history. It has reached out to millions of people displaced by war, persecuted for their religious, political, or social convictions, or merely caught in the wrong place at the wrong time. In 1995 members of the group's Archive Committee, responsible for preserving the photographs and records that document the JDC's history of good works, recognized it was facing a new and serious problem.

The committee realized that during the recent decades of American economic prosperity and relative world peace, people—especially younger people—had begun to lose track of their cultural history, assuming perhaps that the responsibility for taking care of the world's less fortunate is no longer an issue. In a world where the demands of everyday life divert us and often dim our sense of responsibility to others and to the lessons of history, the JDC wanted to get people's attention and remind them that saving lives and preserving cultures is the nourishment of our souls.

What kind of action, the committee wondered, might pierce people's well-armored sense of well-being and jog their indifference toward others in need? What steps might be taken to get Jews and non-Jews to recognize that the nightmares of history are replayed continuously, in different guises and locations beyond the physical and psychological boundaries that we draw around ourselves? Sensing that images speak louder than words, members of JDC's Archive Committee wondered whether its vast archive of photographs documenting more than eight decades of work—photographs that were compiled as a matter of business, used in fund-raising drives and as a resource by historians and scholars—might be used to reaffirm and communicate its goals to old and new audiences.

As curators who are interested in revisiting the information and values embedded in archival photographs, we were asked by the committee to help it solve its problem. Would we evaluate the 50,000 photographs and suggest ways to use the archive to focus a general audience's attention on the importance of history? Might it make sense to present the best photographs not in a Jewish museum but in an art museum setting, where they might trigger discussions about the relevance of history to the survival of cultural identity, as well as about how art can focus attention on social issues?

Even though we knew little about the JDC, we were intrigued by the stories its photographs might tell. In a world where an endless river of images from hot spots becomes a blur, we wondered what meaning such an archive might possess for those who demand novelty and who, when they do look back at history, do so through a haze of nostalgia.

So we set off like explorers on some new continent, ready to navigate the territory. Most researchers who use archives know exactly what they are looking for, and good, organized archives yield information readily. Since we did not start out with a goal in mind, we had to be attentive, to wait until the archive suggested its own story. Flipping print by print through 50,000

archival photographs yielded excitement, boredom, consternation, discovery, and surprise. We expected to see pictures of tragedy, and we did. But most photographs documented the singular determination of people helping people who needed help. There were good pictures and bad ones, old ones and new ones. Pictures taken all over the world—Europe, the Middle East, Asia, Africa, Central America, South America, the Caribbean. A jumble of pictures made by both professionals and amateurs, carefully posed portraits and drugstore snapshots, glass slides of images used to raise money, unique photographic albums lovingly put together, and public relations prints cranked out by the hundreds.

When you're facing 50,000 pictures you move fast. We systematically opened every drawer, took out every folder, touched every picture. Free of ideological persuasion, harboring no particular religious, political, or social point of view and without the blinders of any one aesthetic to direct our attention, we simply set aside pictures that grabbed us, those that were unusual, informative, visually powerful, moving—the ones too good to look at just once. We selected one thousand photographs that stood apart from the rest. The pictures we chose were not necessarily the ones a historian might pick or those that would mean the most to JDC members or to people whose lives were saved by the JDC. We singled out pictures of supplies being packed, stacked, and shipped; of youngsters and grown-ups being fed and retrained for new lives; and there are photographs of migration, crowds of fearful, excited people wondering what would happen to them next. There are countless images of lines of men, women, and children, waving good-bye from ships' gangplanks and from the windows of buses and trains. There are photographs of towns that had been destroyed and rebuilt, farmland plowed and cultivated, doctors and nurses peering into ears, mouths, and eyes, and placing stethoscopes to skinny chests.

Most photographs in the files show people being saved from harm's way, optimistic evidence of the JDC's successes. But no matter how many faces of grateful men, women, and children we looked at, there was no escaping the fact that most people in the pictures had been wrenched from their homes and families, ripped from their native countries. It became impossible not to look for and find evidence of the violence they had lived through, to isolate the tell-tale signs of hardship and oppression in their expressions and gestures.

Ultimately, it was the sheer accumulation of thousands of pictures—taken over eighty-five years by thousands of photographers of millions of people—that made us realize that the powerful and emotionally exhausting experience we were going through was a big part of the story that needed telling. The archive, through the accumulated power of photographs—pictures of responsibility, dedication, determination, compassion; in short, humanness—brought to life for us a humbling message, a reminder of what it means to be human.

If the JDC's goal was to use pictures from the archive to speak to diverse museum audiences about the relationship of images to culture and history, we suspected that our reaction to these images suggested a way to achieve that goal. Why not find a way to translate the experience we as outsiders had had? Given the intensity of our experience and intellectual questions that ricocheted in our minds—about history and archives and memory, life and death and cultural identity, and how images communicate—why not commission artists to make works of art inspired by the archive itself? Since artists are often the people in our culture who help us see the ineffable, we realized that their visions and various responses to their experience in the archive could inspire others to understand and appreciate what the JDC stood for.

We knew we wanted to include artists whose points of view, choice of media, life experiences, and heritages were varied. Some artists whom we approached chose not to participate because they felt the archival photographs were too intense, too real for them to take liberties with. Others, thankfully, were willing

to take a chance and investigate the archive without a clue as to where the experience might lead them.

We settled on eight artists whose commitment to a humanistic tradition is palpable in their work: Magdalena Abakanowicz, Alan Berliner, Wendy Ewald, Leon Golub, Pepón Osorio, Gilles Peress, Fred Wilson, and Terry Winters. All were invited to spend as much time as they wanted in the archive, to investigate its holdings, and meet with JDC workers. No one was obliged to use pictures from the archive in their work; instead they were urged to relate to the images as a source of inspiration. We believed that if each artist were willing to fully engage with the archive's content, they would make works that, when seen together and in relation to images from the files, might get at the powerful relationship between life (as depicted in the JDC photographs) and art (the ways in which artists responded to the photographs). We expected that during the process of investigating the archive each artist would summon up his or her own voice to provide different perspectives on what was important and inspiring about the photographs in the archive.

What we did not expect was the difficulty we faced when it came time to find a museum to host the exhibition and tour the show, problems that took two years to solve. For most art museums the project was too social, too Jewish, or too much about how and why artists make the work they do. No matter how clear we made the issues, most museum directors and curators found the project too risky. They were uncomfortable about taking on an exhibition that featured art-making based on social ideas. They also were uncomfortable about having to live with the uncertainty inherent in commissioned works yet to be made. What we were asking of them required more trust in artists and the art-making process than they had.

The artists, meanwhile, worked on faith, since we could not tell them where the show would open. They did whatever they had to do to penetrate the dense, marginally organized archive, figuring out how to get to what they thought they wanted to see. Some shifted from one idea to another; others did not waver from their initial ideas. They talked to JDC staff and consulted with us from time to time on their works. We interviewed them to make certain their ideas were represented clearly in the show and the catalog, which aims to track the process of the exhibition from idea to installation.

The project was a truly collaborative effort among curators, artists, and the JDC. By the time the artists began researching in the archive at the beginning of 1997, it was clear that we would have to mount and tour the show ourselves. Everyone took a deep breath and pressed on. We persevered and eventually found museum partners adventurous enough to take on the risks and uncertainties of this project, and curators willing to cast their support behind it.

The design of the show presented another level of challenge: how to make certain that the art works spoke on their own, yet still remind people that it was an archive of historic photographs about people in need that inspired the works in the first place. After interviewing a dozen talented prospects we settled on Constantin Boym, for whom designing the space was more than a job. A Russian-trained architect, Constantin had himself been rescued by the JDC in 1981 when it helped him leave Russia for Italy.

It has been an unusual experience for everyone involved in *To the Rescue*—humanitarian workers, curators, artists, designer, and, we expect, visitors to the exhibition. We have always believed that the artists would speak eloquently about the power of history and the human condition. We also believe that making art can stimulate a public dialogue not only about the JDC's work but also about art's place in communicating humanitarian values and having a voice in social issues. In the end, *To the Rescue: Eight Artists in an Archive* is an exhibition about commitment to preserving civilization, caring, and helping other individuals. It is also about insisting that the world we live in and know is not the only real world that deserves our attention.

—Marvin Heiferman and Carole Kismaric

MAGDALENA ABAKANOWICZ

What intrigued you about this project for you to take on this commission? Is it because it relates to the rest of your work?

The project you proposed fascinated me as I nearly saw my face on many photos from the archives. They relate to some of my early life experiences. One cannot look at my work and me as separate entities. The work is one with me. It is my image and my name for those who haven't seen me. It is like sweat, the symptom of my existence.

You can distinguish in my work the images of events I went through as well as signs of an inborn memory and the old heritage of universal knowledge, intuition, sensitivity.

Are there experiences in your life that made you connect to this project and vivify it for you?

I think that in nearly every life of people of my generation are periods or even single moments or even dreams that relate to what you have in your archives. I was nine years old when the II W. W. broke out. My quiet childhood in parents' country estate changed into homeless (which under different forms continues until today). From the beginning we were deprived of identity. I had to learn about the helplessness of my parents, about their resistance and bravery. I had to learn how to defend myself.

My godfather was killed in Auschwitz together with his whole family. They were haunted on the streets like animals with thousands of others. The "death industry" worked. I heard people saying: "Don't buy these brushes, they are made out of human hairs." "This soap must have been made out of human fat, someone found a nail in it."

I remember it was the severe winter 1942. The transport of children from Poland to Germany where they would be turned into Germans was stopped by accident

for a day and a night. Hundreds of blond with blue-eyed children were frozen to death in the not heated cattle trucks.

The war ended not for all. Under the Soviet domination we were seen as class enemies because of our aristocratic background. Some family members were deported to Russian "gulags." No work for my parents, no school for me. How to avoid prison and punishment for the underground activity.

Imagination absorbed the seen and created images from what was told remaining for the rest of life.

Please describe the process of creating your work: visiting the archive, selecting the pictures, the ideas inspired by the pictures, etc.

The process of creation will remain inexplicable whether it is art or science. The technique is a secondary matter. Here I would use the word *inspiration,* which means for me the sudden capacity to see something known with new emotion and to distinguish meanings of it, not yet seen. This is how I selected works that speak about my feelings which were waken up by photos from the archives.

What do you hope to communicate with your piece?

I don't interfere in the impressions of public looking at my art. The work is metaphoric, it has many levels of signification. Viewers would mention: "about human condition in general," "about the phenomena of the crowd," "about our fears and existential anxieties." They would also say: "war, holocaust, solitude." What I am showing is not a statement reduced to only one level of meaning. Art is more than an intellectual message. It expresses more and differently than we can convey in words. This is why it should be left as such without too much explanations as we can easily explain it away.

How can historical images of a specific group of people at a particular point in time be used to communicate to contemporary, culturally diverse audiences?

I think the most important for such precious images is to find for them the right context. As long as images are closed with themselves they live like exotic plants in a botanic garden. One plant taken out, to the everyday reality can shock as something unexpected, can attract attention, can become a source of important emotions and inspirations.

What do you understand to be the role of your art in relation to social issues? What kind of dialogue can socially committed art trigger?

Art is an astonishing activity of mankind deriving from constant struggle between wisdom and madness, dream and reality under our skull. Art is above fashions, politics, social problems. They are temporary tendencies losing or gaining importance with time. Art remains.

MAGDALENA ABAKANOWICZ was born at her parents' country estate in Falenty, Poland, in 1930. Her childhood was brutally interrupted by World War II, followed by German, then Russian, occupation of her country. She studied at the Academy of Fine Arts in Warsaw and graduated in 1954. She began her career as a painter, then moved toward making sculpture, first abstract, then figurative. She creates large groups of 40, 80, or 100 figures. There might be as many as a thousand, but they have never been seen together. They remain in various public and private collections. With these sculptures Abakanowicz makes her statement about the human condition. Abakanowicz also creates monumental outdoor permanent installations using stone, bronze, and steel—"spaces to contemplate"—in Italy, Israel, South Korea, Japan, Germany, and Lithuania. In the beginning of the 1990s she designed ARBOREAL ARCHITECTURE, a model of an ecological city in which she transformed houses into vertical gardens. She also creates and choreographs dances that derive from her sculpture experiences. They have been performed on the occasion of her exhibitions in Tokyo, Hiroshima, and Warsaw. Abakanowicz lives and works in Warsaw.

Abakanowicz has been a professor at the Academy of Fine Arts in Poland and a visiting professor at UCLA. She received honorary doctorate degrees from the Royal College of Art in London, the Rhode Island School of Design in Providence, and the Academy of Fine Arts in Lodz, Poland. She is the recipient of the Grand Prix of São Paulo Biennale (1965), the Comandor Cross of the order of Polonia Restituta, Chevalier dans l'Order des Arts et Lettres in Paris, the Leonardo da Vinci Prize in Mexico, and the Award for Distinction in Sculpture, granted by the Sculpture Center in New York. Her works are in many public collections, including the National Gallery in Washington, the Seson Museum in Tokyo, Musée d'Art Moderne in Paris, the Ludwig Museum in Cologne, the Center for Modern Art in Warsaw, and the Museum of Modern Art in Seoul.

It does not solve problems but makes us aware of their existence. It opens our eyes to see and our brain to imagine. I remember the terrifying Hitler doctrine "Art for the population" (*Kunst dem Volk*) that brought great artists into prison or exile. I went through the experience of "socialistic realism" imposed upon us by Soviets. I remember very well its pressure

I BELIEVE THE SOCIETY NEEDS THE ARTIST AS A SHAMAN RISING THEIR IMAGINATION, QUESTIONING THE EXISTENCE, DEVELOPING SENSITIVITY, MAKING THEM AWARE OF PROBLEMS THEY HAVEN'T THOUGHT ABOUT.

on the creative freedom and the deep destruction of culture it caused. Art is a necessity integrated into human nature. In the very first graves of *homo sapiens* one could find tools to produce what we call now "art." There was already the need for something more than just survival. I believe the society needs the artist as a shaman rising their imagination, questioning the existence, developing sensitivity, making them aware of problems they haven't thought about.

If the JDC's work is to help people, what is the work of an artist?

An artist with his world, imaginary and real, his metaphors and dreams, constitute a condition of our equilibrium.

With my art I oppose the cruelty and hypocrisy of the official history, the small, pure, helpless, but marvelous history of the individual human life with its truth, sincerity, and greatness.

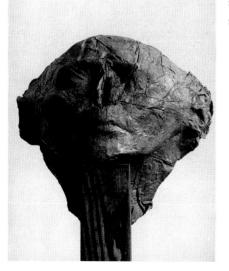

From the cycle ANONYMOUS PORTRAITS, 1985. Cotton and wood.
27½ x 7⅞ x 7⅞ in.

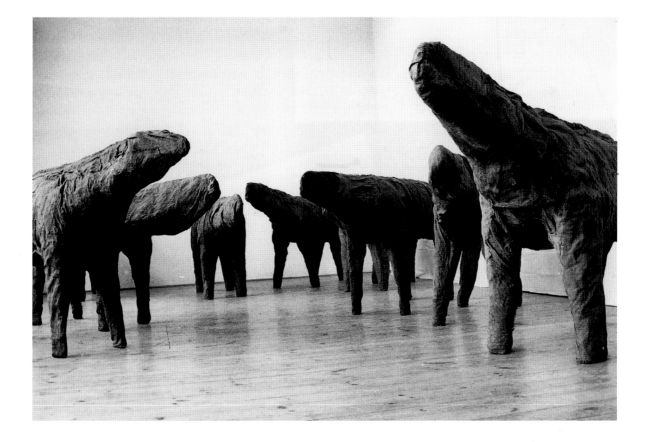

STANDING MUTANTS, 1992–1994. 14 figures. Burlap and glue on metal frames. Each 43¼ – 49¼ x 17¾ – 19¾ x 90½ – 98⅜ in.

For this exhibition Magdalena Abakanowicz combines sculptural elements drawn from two previously completed works that, seen in the context of this exhibition, take on new meaning. For the installation at the International Center of Photography a selection of figures from two groups—adult-sized figures from CROWD IV (1989–1990), and smaller figures from the 1992 cycle INFANTES—will be shown together. In subsequent venues figures from the INFANTES cycle will be shown as a group, with the work being reconfigured for each site on the exhibition tour. Abakanowicz's groups of headless figures, made of burlap stiffened with resin, are meant to be confrontational. Seen as a group and from a distance, the figures appear identical but are individually distinct when viewed closely. Viewed from the front, these upright figures stand aggressively and in formation; seen from the back, they look vulnerable. They are both mute and eloquent, soldiers and victims. While some observers have suggested that these figures might be interpreted as metaphors for the physical and psychological damage done by World War II and the totalitarian politics in postwar Eastern Europe, Abakanowicz keeps the work purposefully ambiguous and full of contradictions. The critic Michael Brenson has said of her work, "Every one of Abakanowicz's sculptures . . . carries the weight of a story that remains beyond its grasp. Sometimes the stories suggest ancient horrors endlessly reenacted . . . however, each of her sculptural bodies also seems to have the ability to generate a narrative that is entirely new."

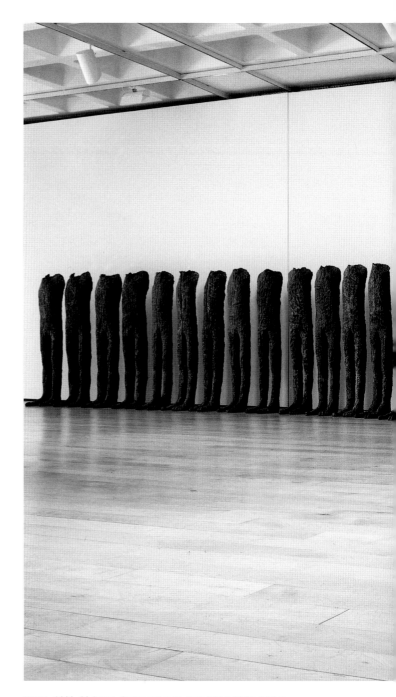

INFANTES, 1992. 33 figures. Burlap and resin. Each 55⅛ x 11½ x 11¾ in.

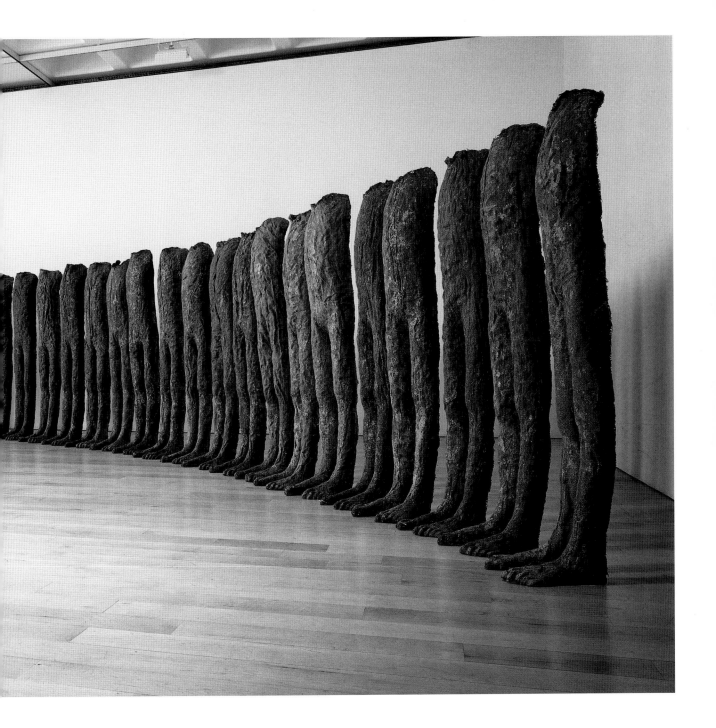

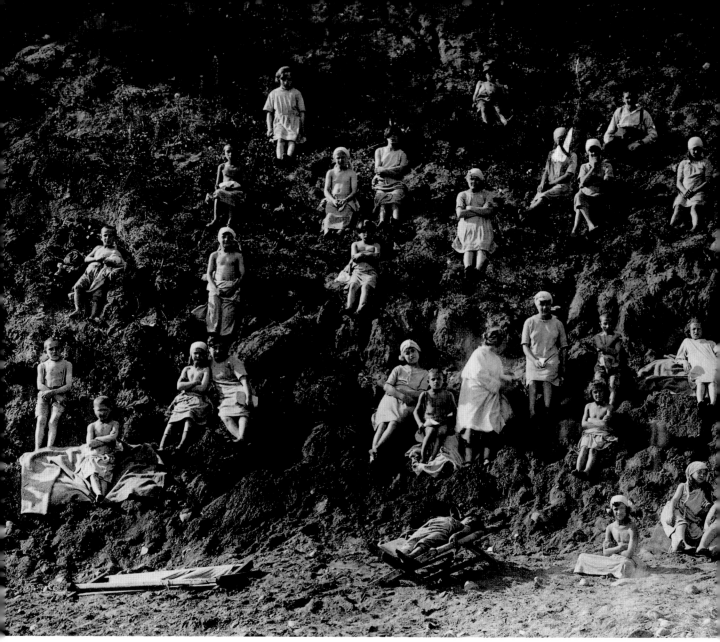

1920 JDC recruits American social workers to work in Europe. In February the first JDC Overseas Unit—126 doctors, health and social workers, and a rabbi—reach Poland.

JDC sponsors a food distribution center in Jassy, Romania.

1921 JDC launches a program that helps bring Jewish war orphans to America.

Summer colony in Nonosiolki, district Bialystok, Poland, 1926.

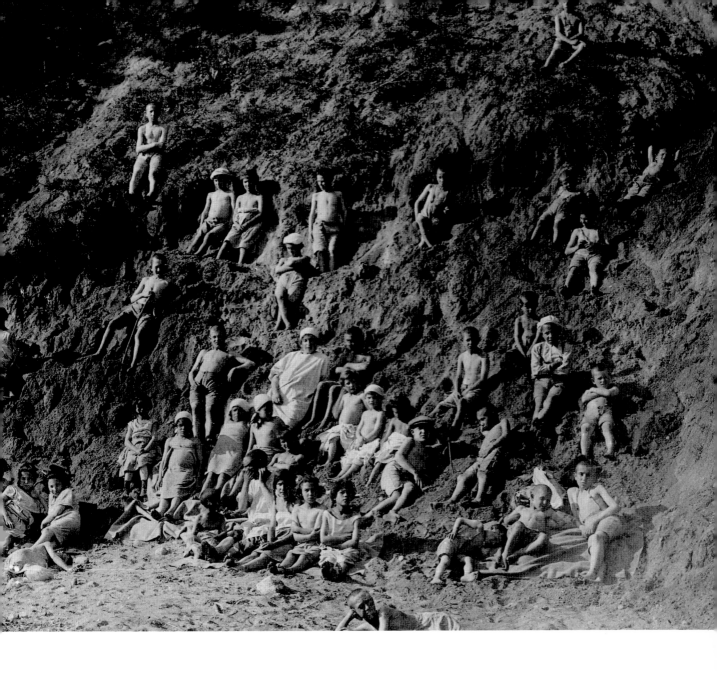

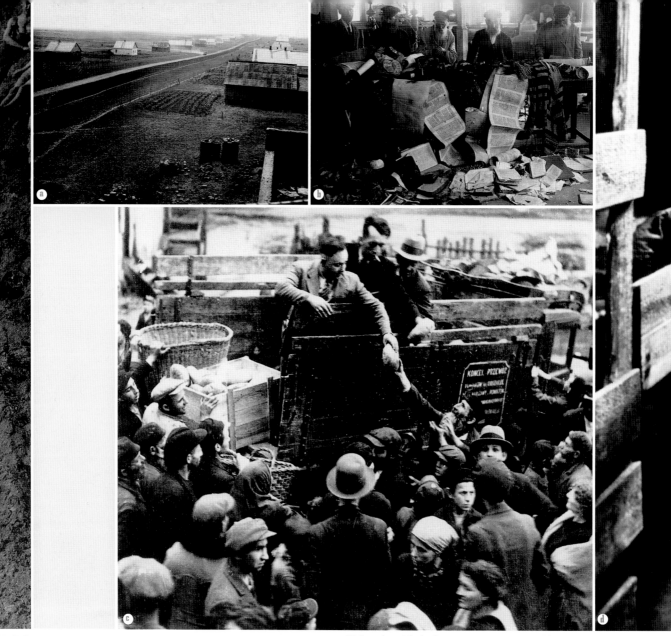

1924 To promote economic self-sufficiency among the Jews of Eastern Europe the JDC establishes the Reconstruction Foundation, which creates low-interest credit unions to help individuals get back on their feet.

JDC works with the Soviet government to establish Agro-Joint, a program to resettle Jews on land in the Ukraine and Crimea. By helping previously existing agricultural colonies and establishing new ones,

a View of Tagancha, an Agro-Joint site in the former Soviet Union, c. 1924. b At the Demieff Synagogue in the former Soviet Union thirty torahs were destroyed in May 1920. c Distributing bread to Jews in need in Poland, 1920. d Eastern European family, c. 1929.

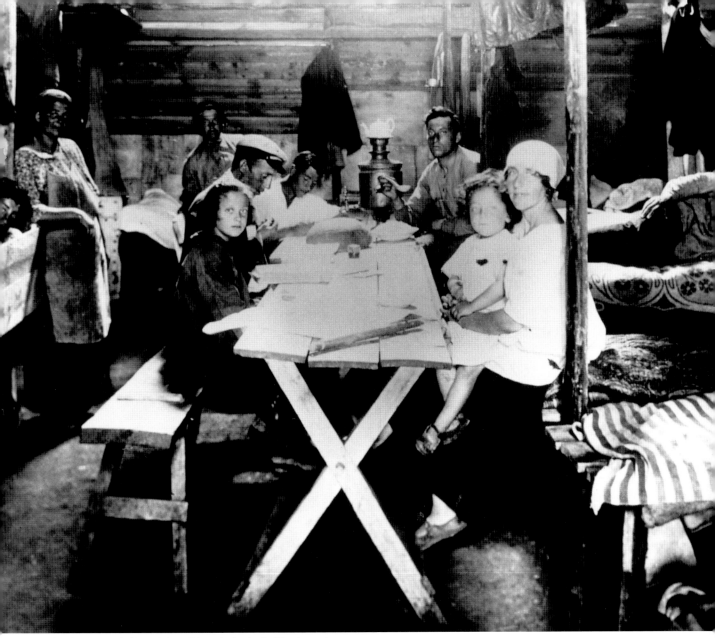

5,646 families are settled in 112 Agro-Joint colonies in the Ukraine and 105 in the Crimea between 1924 and 1928. (By 1938 60,000 will have new homes.)

ALAN BERLINER

As both a filmmaker and a media artist—especially one who works a lot with found and appropriated materials—I'm always on the lookout for new and unusual audio and visual elements that I might someday find a way to work with. Over the years I've accumulated a rather elaborate personal archive, filled with many old photographs, films, slides, books, magazines, postcards, audiotapes, record albums, videotapes, and other odds and ends. I've also gathered a small but special collection of old family photo albums. My primary sources for many of these things have been flea markets, junk shops, and garage sales.

About twenty years ago I was living in the midwest and found myself one early Sunday morning at a garage sale in a typical suburban neighborhood. Scanning the usual assortment of miscellaneous household clutter, my eyes focused on an old family photo album. If I remember correctly, the price was ten or fifteen dollars, quite reasonable for an antique-looking if somewhat frayed collection of about 100 black-and-white photographs that appeared to have been taken sometime in the 1930s.

Eureka! A find. A steal. What a great way to start the morning. As I took the money out of my pocket, something made me ask the young girl behind the table if she knew anything about the album. She said she wasn't sure, but thought that it contained old pictures of people who in some way were related to her family.

In the midst of my glee—wasn't I the perfect customer for this old book of images? I already had a collection of similar photo albums; I would protect it, treasure it, study it, maybe use it in a work one day—I suddenly stopped short. Something felt wrong. It was one thing to purchase an album from flea market vendors or junk shop owners who salvage personal memorabilia from estate sales and other third-party sources; it was another

to purchase one from the very family of its origin. Ethically. Aesthetically. I had a problem.

I asked the young girl if her parents were around and whether I could speak to one of them. When her mother finally came out, I gently implored her not to sell the album. Not to me. Not to anyone. Ever. I told her that one day, someone—her children, her grandchildren, her great-grandchildren, or some other relative—might ask about it, want to see it, would discover it no longer existed, and would deeply regret its loss. It was too precious to sell. I suggested that she just put the album away for now. She seemed to agree, half-heartedly chiding herself for making such a foolish mistake.

I left the garage sale with mixed emotions. I certainly felt a deep sense of relief that I had done the right thing, but I also had a queasy premonition that I had merely been indulged; that the album had probably gone right back for sale immediately after I left. To this day, when I look through the other family photo albums in my collection, I wonder what stories of indifference, ignorance, or tragic circumstances allowed them to become exiled and orphaned from their families of origin.

Within my own extended family, both maternal and paternal, I am the keeper of the memory: the family archivist, historian, and guardian of virtually every important photograph and family document. I have done a great deal of research, had old photographs repaired and restored, foreign language documents and letters translated, and made everything available to any family member who expressed interest. If the truth be told, few if any ever have. But this personal family archive has led to the creation of my two most recent films, *Intimate Stranger* and *Nobody's Business,* each of which idiosyncratically explores a distinct half of my family heritage.

It feels like I've always had this impulse to collect. My uncle says I inherited what he mischievously calls "the saving gene" from my maternal grandfather. But it's important to note that I don't collect things with any intrinsic monetary value. I just save things in the service of my ongoing work, acting as a kind of *bricoleur* who gathers, accumulates, and assembles things, ideas, and meanings as he goes along. I do owe a debt of gratitude to my grandfather, whose weekly gift of postage stamps from all over the world helped establish my first image bank at the age of seven. My first private archive. Thousands of tiny little images. Photographs. Frames. I treasured them. Memorized them. Spent countless hours ritually organizing them. Landscapes. Languages. Colors. Icons. World leaders. Historical events. And on and on. Little did I know that was teaching myself some of the crucial skills of filmmaking.

When I was invited to participate in this exhibition, it felt as if I had been

ALAN BERLINER is a filmmaker and media artist. His award-winning and critically acclaimed experimental documentary films are in the permanent collections of many libraries, festivals, universities, archives, and museums worldwide. THE FAMILY ALBUM (1986), a collage of American family home movies and audio recordings, was included in the 1987 Whitney Biennial and received the "Experiments in Form" Award from the 1992 San Francisco International Film Festival. INTIMATE STRANGER (1991), a biography of Berliner's maternal grandfather, received a Distinguished Achievement Award from the International Documentary Association in 1993. NOBODY'S BUSINESS (1996), a portrait of his father, Oscar, received the International Film Critics Association Prize at the 1997 Berlin International Film Festival and "First Prize for Innovation" at the 1997 Festival Dei Popoli in Florence. Berliner's films have been described by the NEW YORK TIMES as "powerful, compelling, and bittersweet . . . innovative in their cinematic techniques . . . unpredictable in their structures . . . illustrate the power of fine art to transform life."

In addition to his films Berliner has produced a substantial body of audio and video installation works. AUDIOFILE (1993) and AVIARY (1993), both interactive audio installations, were exhibited at New York's Lincoln Center in 1994. His first solo exhibition, FOUND SOUND, was held at Sculpture Center Gallery in New York City in 1996. Alan Berliner has received grants and fellowships from the Rockefeller Foundation, the Guggenheim Foundation, the National Endowment for the Arts, the New York State Council on the Arts, the New York Foundation for the Arts, and the Jerome Foundation. He is the winner of three Emmy Awards, and retrospectives of his films have been presented at the Museum of Modern Art and the International Center of Photography in New York.

preparing for it my whole life. The initial title for the exhibition read "Artists in an Archive." Each of us was to make a journey into the Joint's photo collection, and navigate through a pool of images so extensive and varied that it still has yet to be fully catalogued. Like being let off at the edge of a vast wilderness without a map. I was told to immerse myself. In my own way and at my own speed. No rules. Just come up for air with the inspiration for a new work. This was music to my ears. And sounded familiar.

For instance, in 1986 I purchased a rather large collection of 16mm black-and-white home movies, representing some seventy-five families of mixed racial, religious,

ethnic, and class origins, taken from the mid-1920s through the late 1940s. After spending close to a year studying the more than fifty hours of material, I began work on a film titled *The Family Album,* which ultimately became a complex collage of sounds and images, exploring the celebrations, struggles, conflicts, and contradictions of American family life. Like my collection of family photo albums, virtually every face in the film is anonymous, without a name or a story. Celluloid orphans.

By juxtaposing and counterpointing a wide range of intimate sounds—including found and donated recordings of oral histories, birthday parties, weddings, funerals, anniversaries, holiday gatherings, music lessons, audio letters, and just plain old fly-on-the-wall arguments in the kitchen—with hundreds of different home-movie images, *The Family Album* gives the myriad nameless faces in the film new but provisional identities. And a strange kind of (cinematic) immortality.

To the extent that I understand it, my internal compass has always been calibrated by an intense kind of listening. Being attuned to the dialectical pushes and pulls, and an intuitive feeling for the boundaries—inside and outside—of whatever aesthetic territory I enter. When I first arrived at the Joint's photo archive, my first instinct (and compulsion) was to look at every single photograph. And indeed, over the course of many hours, days, and weeks, I did empty many shelves completely. Suffering the patience. Box by box. Folder by folder. Image by image. Taking notes along the way.

I never did get all the way through. Something stopped me. A memory. One afternoon, as I was pondering the weary smile on the face of an elderly Jewish man, I recalled something my father said to me in my film *Nobody's Business* when I showed him photographs of his Polish grandparents for the very first time. "He looks like another old

EVERY NEW FACE I CAME UPON—WHETHER MELANCHOLY, SERENE, YOUTHFUL, WRINKLED, STRONG, POWERFUL, TIRED, OR FRAIL—BEGAN TO RESONATE AS A LINK TO SOMETHING I'D FORGOTTEN. OR NEVER KNOWN. A LOST CULTURE. A VANISHED COMMUNITY.

Jew with a yarmulke! . . . That's all. . . . I have no emotional response. . . . They could be taken out of a storybook, I don't know them. . . . They mean nothing to me." He was saying that the faces of his grandparents were, in effect, generic. That without any specific history, experience, or memory to hold on to, their reality as relatives, as people, as faces, and as photographic images was absolutely arbitrary.

Staring down at the growing pile of photographs made me realize that in some way my father was correct. Each of these anonymous faces could just as easily be my grandparents, great-grandparents, or some distant relative. They certainly looked the part. And for the Ashkenazi part of my heritage (I'm also half Sephardic), it's more than remotely possible that we are somehow related. In fact, some genealogists estimate that most Jews of Eastern European descent are probably somewhere between eighth and twelfth cousins.

Reflecting further on my father's cynicism allowed me to open up to these images. Every new face I came upon—whether melancholy, serene, youthful, wrinkled, strong, powerful, tired, or frail—began to resonate as a link to something I'd forgotten. Or never known. A lost culture. A vanished community. A transcendent mirror for my own complicated assimilation as a late twentieth-century American Jew. Became family.

Somehow I had come upon an understanding of the Joint photo archive as a kind of collective "family album" of the Jewish people. For me, the intentional anonymity and open-endedness of the photographs in *Gathering Stones* invites each viewer to invent his or her own way of measuring the distance between private and collective memory, between family member and stranger, between the living and the dead. By transforming the idea of a family album—a powerful emotional symbol of preservation and memory—into a site of commemoration, the anonymous images in *Gathering Stones* can become imbued with personal and mythic dimensions. Yes, indeed, my father was right. These people could be anybody. And they are.

From NOBODY'S BUSINESS, 1996.

A time to mourn and a time to dance;
A time to cast away stones and a time to gather stones together.
—Eccles. 20:20

A participatory video installation, GATHERING STONES incorporates portrait photographs from the archives of the JDC and projects them in a series of orchestrated sequences onto the "pages" of a monumental photo album made from a bed of stones. The open pages of the album are represented by two large rectangular fields of small black pebbles. Five small rectangles of white stones are placed on the black pebble background, onto which five suspended video projectors beam five distinct, tightly focused sequences of images. The stones are meant to recall and evoke the Jewish ritual custom in which cemetery visitors place a small stone on a grave marker as a symbol of remembrance, signifying a connection with Jewish history, memory, and community; between the living and the dead.

At the entrance to GATHERING STONES is a pile of small white stones, acknowledging this tradition. As a gesture of participation and commemoration, the visitor is encouraged to take one of these stones and add it to any one of the five rectangles of the "album," thereby slightly altering the "screen" on which the changing images are projected. This activity transforms the book of remembrance into a ceremonial site, intended to give renewed dignity to the memory of the people in these archival photographs and to acknowledge an enduring bond with them—then and now— as our collective ancestors.

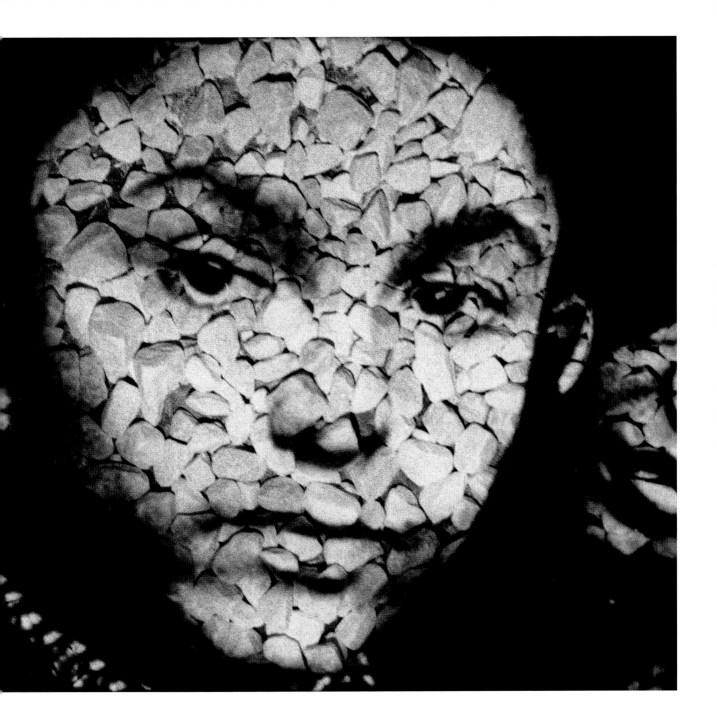

1933 Hitler is named Chancellor of Germany on January 30. On April 1 the Nazis institute a boycott of all Jewish stores and professionals, and restrict the number of Jewish children who can enroll in schools. Anti-Semitic policies cause some 40,000 German Jews to try to leave the country. The JDC continues its support of the German Jews by working with the Zentral Ausschuss für Hilfe und Aufbau (ZA), an umbrella organization of welfare, educational, emigration, and training organizations providing economic aid to merchants, vocational guidance

a Residents of Sosua, a JDC agricultural settlement for Jewish refugees in the Dominican Republic, c. 1938.

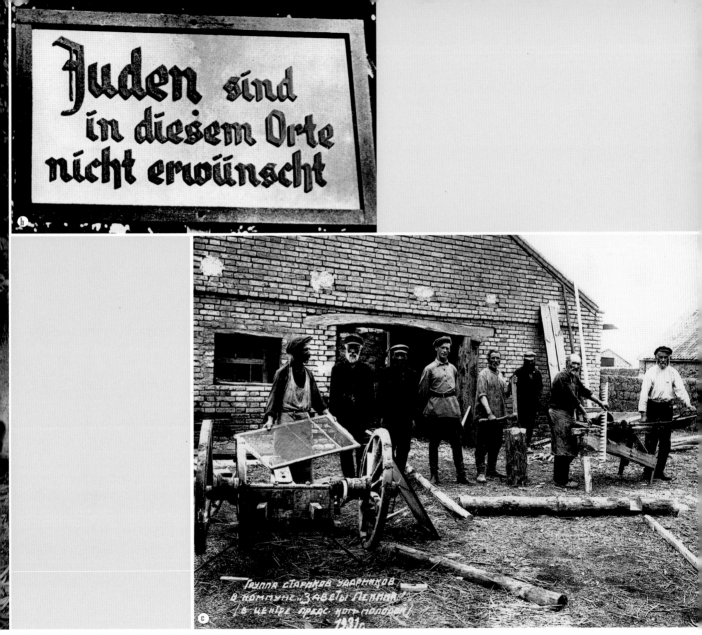

and training for youths, education to Jewish children, and occupational readjustment programs for older Jews in Germany. JDC moves its headquarters to Paris and is able to maintain the Berlin office until 1939.

b "Jews Are Not Welcome Here." Germany, 1935. c Residents of an Agro-Joint communal agricultural settlement in the former Soviet Union, 1931.

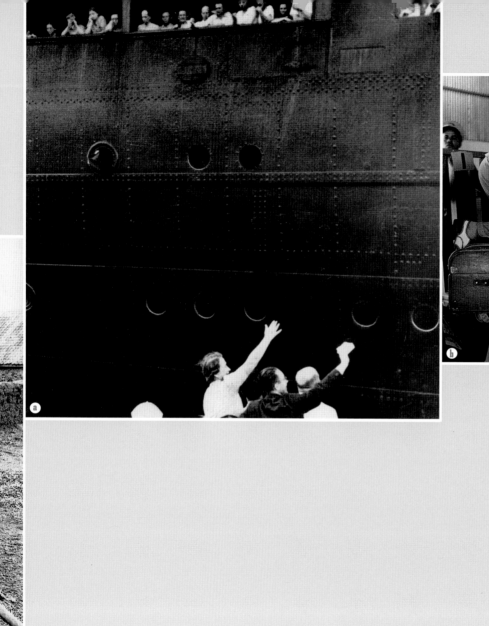

1938 President Roosevelt invites JDC representatives to join an advisory committee for the Evian Conference on refugees from Germany. The United States, however, fails to change its immigration laws and little progress is made in finding havens for Jewish refugees, except for the establishment by JDC of Sosua, a Jewish settlement in the Dominican Republic.

a Passengers aboard the SS *St. Louis* arrive in Belgium, 1939. Belgium, England, France, and Holland were the only countries that would accept the refugees. Only those taken to England escaped the Holocaust. b After an inspection by customs. Dominican Republic, c. 1939. c A Jewish home destroyed in anti-Semitic demonstrations in Poland, c. 1930.

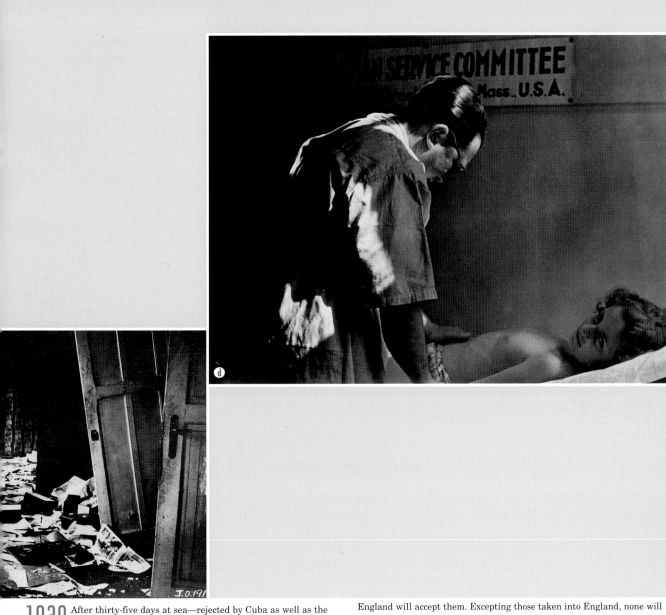

1939 After thirty-five days at sea—rejected by Cuba as well as the United States, despite valid visas—over 900 Jewish refugees on the SS *St. Louis* get word from JDC: Holland, France, Belgium, and England will accept them. Excepting those taken into England, none will escape the Holocaust.

ɗ A doctor examines a young girl in preparation for her departure to the United States, c. 1934–1936.

WENDY EWALD

The JDC archive documents how a Jewish community takes care of itself, a moral concern that touches us all. It is about our responsibility to each other, and because it is the archive of a relief organization, I decided to pose questions that would help me better understand how we see each other, how we are different, and how we are the same.

I've spent considerable time in the archives. The children I am working with have not, and my biggest challenge has been how to communicate my experience to the kids so that the images I saw became part of their own experiences.

When I was in the archive, I found these before-and-after publicity pictures of World War I orphans that had been used by the JDC to gain support for their relief effort. I was most drawn to portraits of children who had just entered a JDC house or community. They were wearing clothes that were disheveled and torn. The "after" pictures were pretty much the same—the kids were in the same position, only with new clothes on. Their expressions hadn't changed. Everything was the same except for the clothes. They looked stunned. They'd probably never had their picture taken before. Visually, these pictures captured my attention the most, but there wasn't enough information about them for me to use them with the students. Then I found photographs of children taken during World War II. The kids in these pictures were smiling, and I was struck by the difference between them and the ones from World War I. The photographers felt they had to make the children appealing. But these pictures also didn't provide enough information—until I found the case histories attached to the photographs, with the story to fill in the blanks. The words provided the fuller reality that the picture couldn't possibly show. Those images and stories became the core of what I wanted to work with, and since my concern was to help the kids make some part of World War II real for themselves, I felt that matching the kids

with a photographic counterpart made the most sense. I matched them up by age, gender, things like that.

But first, I wanted to know how much the kids understood about the war. They hadn't experienced it in their own lives. Who knew what they'd learned about it from their family, their community, books, and movies? There could be a lot of room for imagination. I asked them to write about what they knew about Jews and Nazis and, as I suspected, they knew very little. I wanted to play off of this—their lack of knowledge, their lack of a sense of a continuing history—in the piece I was going to make. I was also curious about what portion of our history was getting lost and how an archive might be used to counter that loss. So I showed them a picture of a little boy in a concentration camp, someone with an amazing case history. When I first showed the picture to the kids, they laughed. They said things like "He's got big ears," the way kids do. And then I read them his case history. I started reading to them slowly, and there was complete silence; their jaws dropped open.

In the concentration camp there were two lines. One line was for people who were going to be exterminated, one was for people who were going to do hard labor. His parents were put in the hard labor line. He was two and a half years old, and he was put in the extermination line. And his father saw a sack, and picked the little boy up and put him in the sack and told him not to be afraid. They both survived the war. That was the story. When I finished, I gave the kids their pictures and case histories. Some kids said, "No, I want that one," and so they traded. The teachers and I asked them to read through the case histories and look for vocabulary they didn't know; they learned new words like *tragedies* and *extinction*. Then I asked them to write about the kids in the photographs in the first person, as if they were writing about themselves.

The kids became passionate about learning more about their person. They did research on the war, wanting to know what life was like for this person in the picture. They learned about persecution and witnessing crimes and injustice, things they encounter in their own lives. They were absorbing so much about history by rooting history in the personal that I can't imagine them learning about it in a way that would have more meaning for them.

The children in the archive pictures had no power to do anything, and here were kids looking at these pictures decades later, many of them African Americans with less power than many other kids in this country. I decided that if I wanted to explore power relationships, I needed to make an installation that would somehow have these students and the

WENDY EWALD has for thirty years collaborated in art projects with children, families, women, and teachers in Labrador, Colombia, India, South Africa, Morocco, Saudi Arabia, Holland, Mexico, and the United States. Starting as documentary investigations of places and communities, Ewald's projects probe questions of identity and cultural differences. In her work with children she encourages them to use cameras to record themselves, their families, and their communities, and to articulate their fantasies and dreams. Ewald herself often makes photographs within the communities she works with and has the children mark and write on her negatives, thereby challenging the concept of who actually makes an image: who is the photographer; who the subject; who is the observer and who the observed. In blurring the distinction of individual authorship and throwing into doubt the artist's intentions, power, and identity, Ewald creates opportunities to look at the meaning and use of photographic images in our lives with fresh perspectives.

Wendy Ewald has received many honors, including a MacArthur Fellowship and grants from the National Endowment for the Arts, the Andy Warhol Foundation, and the Fulbright Commission. She has had solo exhibitions at the International Center of Photography in New York, the Center for Creative Photography in Tucson, the George Eastman House in Rochester, Nederlands Foto Instituut in Rotterdam, and the Centre for Photography as an Art Form in Bombay, India. She has published four books and her fifth, a retrospective documenting her projects, will be published in 2000 by Scalo Books. She is currently a research scholar at the Center for Documentary Studies at Duke University.

pictures from the archive present in the room at the same time. So I created a two-screen video installation that involves them both. In it, individual children speak to the camera in their persona of the kid in the JDC photograph. By showing the student's performance on one screen and an image of a child from the archives on the second, or juxtaposing what a student wrote before studying the war and archival photographs showing what it was really like, I wanted to create a tension between the imagined and historical reality. The impact of history on the kids will be in the space between the "reality" of history and the child's fantasy.

I THINK MANY PEOPLE ARE INTIMIDATED BY ART BECAUSE THEY DON'T UNDERSTAND HOW THE ARTISTS ARRIVE AT THEIR WORK. I WANT TO SHOW PEOPLE HOW MY WORK COMES ABOUT. I WANT TO SHOW THEM THE ISSUES I WANT TO ADDRESS SO THEY CAN PARTICIPATE.

The motivation for all the work I do is political. I believe that the more information you have, the more choices you have. What interests me is how things work—how governments work, for example, or institutions—and how people see things. I believe that the more information there is, the more you understand. I think many people are intimidated by art because they don't understand how the artists arrive at their work. I want to show people how my work comes about. I want to show them the issues I want to address so they can participate. For example, in one of my projects, I asked African American and white children to write about themselves and then imagine themselves as a member of the other race. I then photographed each as their black self and white self. In the final work, the viewer can see how the kids are reacting to the issues of race and power; and they're forced to examine how they themselves react to the same issues. In my work, the issue, the dialogue, is, I hope, already there, so a personal response to it doesn't diminish its strength. And the audience is not threatened by the work, because the viewer is likely to trust the children involved in the project, their brightness, their honesty.

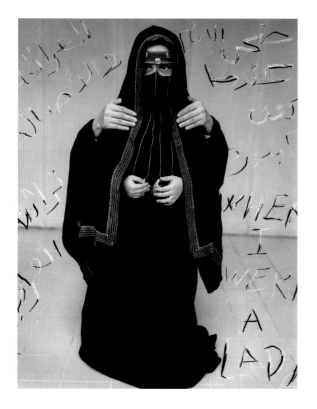

"Nadine Holding Her Daughter" by Nadine Faisal Binzagler and Wendy Ewald, from THE SAUDI SERIES, 1997. 46 x 36 in.

From BLACK SELF/WHITE SELF by Wendy Ewald and Gregory Blake, 1995. 46 x 36 in.

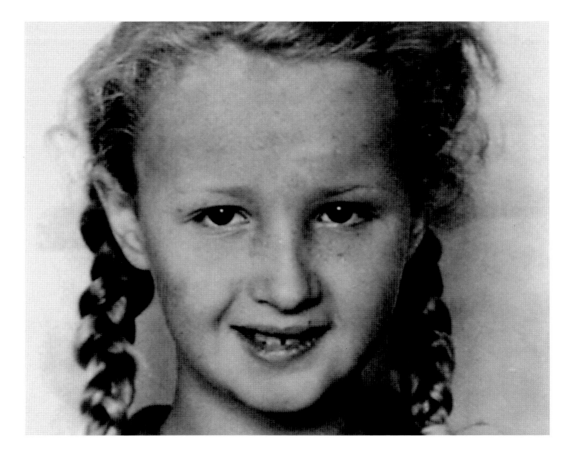

When Wendy Ewald started thinking about this project she wanted to explore the purpose of an archive as a repository of human memory. She decided to make a video installation that explores history that has been lost and attempt to bring the past into the present.

From the archive Ewald chose photographs and case histories of children who had survived World War II. She arranged to work with two classroom teachers in the recently integrated Durham, North Carolina, school system, many of whose students face issues of race and minority persecution every day.

Ewald felt that students would draw on their personal experiences to understand the adversity faced by the children whose lives they were going to study.

Each participating elementary school student was given a photograph and case history of a child and shown other photographs from the archive that illustrated what Jews' lives were like during the war. Afterward the students wrote three short pieces: first they imagined themselves as the displaced children in the photographs, then as witnesses to the Holocaust, and finally, as the children of Nazi sympathizers.

Tzipora Greenfeder and Crystal Garner

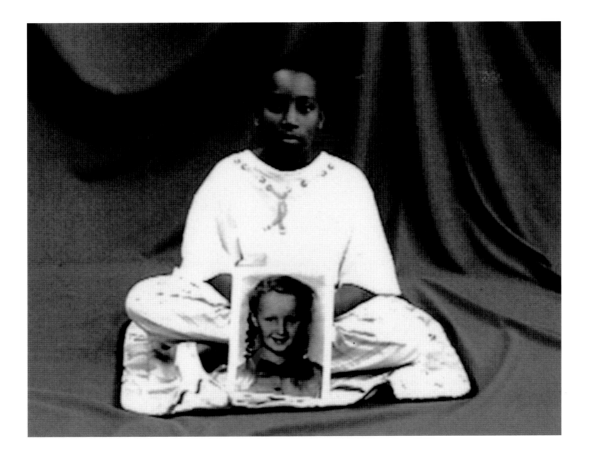

Ewald asked each student to memorize and perform one of their written pieces, which she then video-taped.

The two-screen video installation in this exhibition includes performances of pieces the students wrote, their drawings and writings, and the objects (dolls and bits of clothing, and so on) they might have chosen to keep with them as "refugees," as well as related photos from the JDC archive. In the students' performances we simultaneously see the children as themselves and as their imagined characters reacting to the Holocaust.

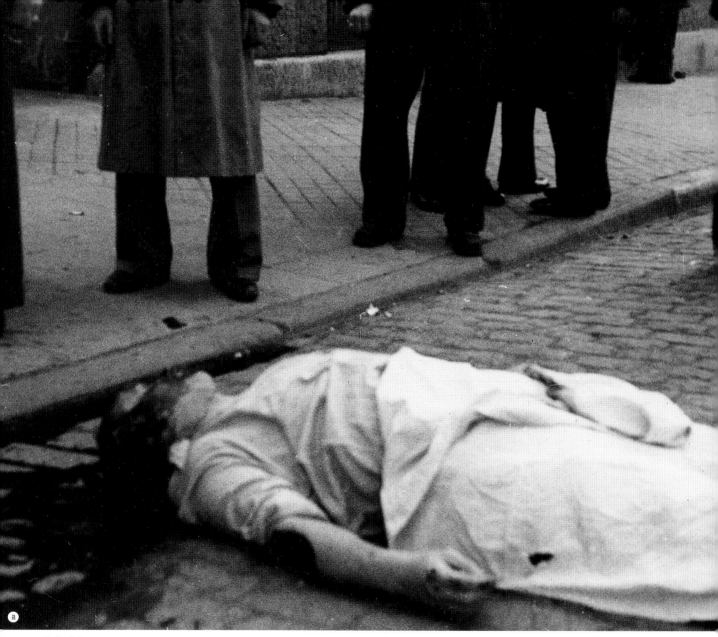

1941 China is the last country to maintain an open-door policy to Jews fleeing Nazi-occupied Europe. JDC sends a staff of two to organize the Shanghai Jewish community of 20,000—nearly half of whom are on relief.

1942 JDC organizes relief packages through Teheran for Jewish refugees in Russia. In five years more than 250,000 life-sustaining packages of food and clothing are sent.

a Body of Samuel Danciger, a thirty-seven-year-old former concentration camp inmate, who was shot through the head by a policeman after a clash between the German police and unarmed Polish Jews in a displaced persons camp. Lansburg, Germany, 1946.

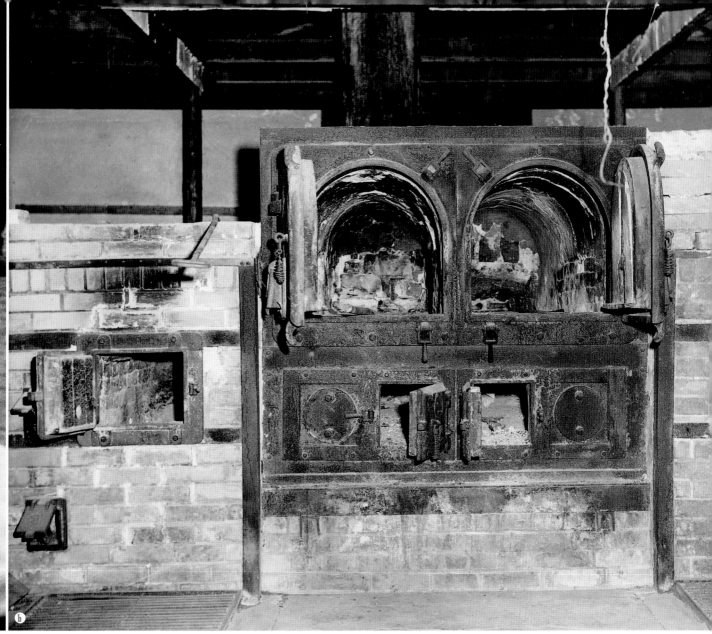

1945 As the war in Europe ends JDC organizes a massive relief effort. By the end of 1947 700,000 Jews will come to rely on JDC for aid. More than 250,000 are in displaced persons (DP) camps sponsored by the JDC. (Those helped by JDC include Oskar Schindler, a non-Jew who helped rescue Jews during the Nazi era.)

To assist Holocaust survivors immigrating to South America, JDC opens an office in Buenos Aires.

ʰ Crematorium at Dachau concentration camp, Germany.

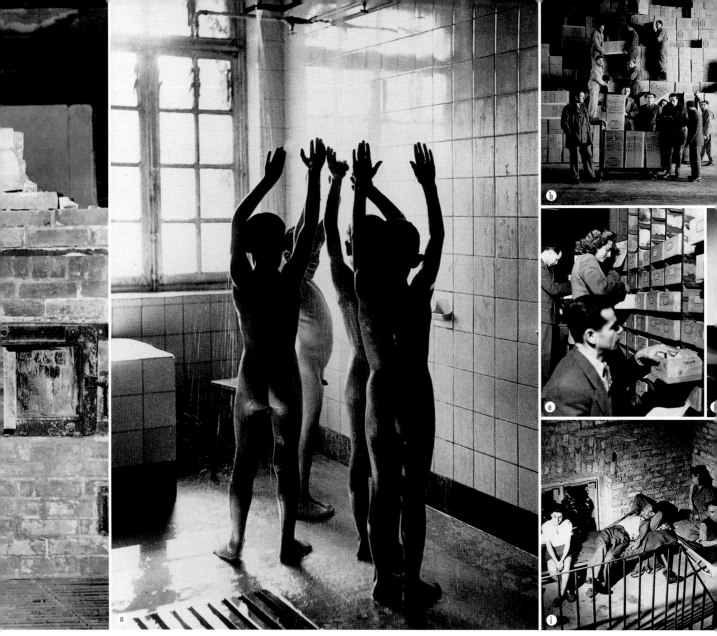

1946 JDC sends supplies collected by Supplies for Overseas Survivors (SOS), an organization that sponsors drives for food, clothing, and medicine. In thirty-nine months fourteen million pounds of food and twelve million pounds of clothing and medical supplies are donated.

1947 JDC establishes the Paul Baerwald School of Social Work in Versailles, France, to train social workers to teach and practice in over a dozen different countries.

a At a children's home for war orphans. Belgium, 1947. b Loading matzoh for transportation to the DP camps. Munich, 1949. c JDC representatives reviewing relief projects in South America, c. 1946. d Two babies born to displaced Jewish mothers in JDC's prenatal and maternity center in Ulzen, Germany, 1946. e JDC workers in France, 1946. f Relief package, 1946. g Seder table at an orthodox home for thirty-five children in Belgium, 1947. The children raised chickens, sheep, and ducks and grew flowers, fruits, and

1948 Israel is founded. Between 1948 and 1950 JDC's "Operation Magic Carpet" brings the entire Jewish population of Yemen en masse to Israel.

1949 JDC establishes JDC/Malben in Israel to care for the disadvantaged among aged and disabled immigrants.

JDC intensifies operations in Tunisia and Morocco, where Jews have been living in poverty for generations.

vegetables. **h** Receiving new clothes from a transient center in Munich in preparation for emigration to Israel, 1949. **i** Every inch of space in Rothschild Hospital—including the fire escape—is used to care for Jewish refugees from Romania. Vienna, c. 1947. **j** SOS (Supplies for Overseas Survivors) trucks. United States, 1949. **k** Survivors line up to receive medical attention. Czechoslovakia, 1946. **l** A father bound for Israel carries his child and belongings up the gangplank. Venice, 1949.

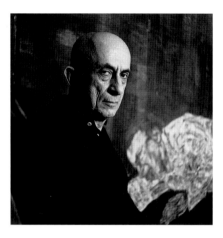

LEON GOLUB

In visualizing a project inspired by the role that the JDC has played in the rehabilitation, relocation, and the offering of new lives to the stricken Jews of Europe and elsewhere, I wanted to document the resistance of the Jews as partisans during the years of the Holocaust. While the time frame of the JDC's extensive photographic archive is primarily post–World War II, I shifted my work's time frame earlier, to the time of the extraordinarily difficult struggle of resisting the Nazi domination of Europe, to picture those who, recognizing that they had virtually no expectation of survival, refused to go to the slaughter without fighting back.

As an artist I have tried to work through visual imagery that inscribes events, a reportage concerning power, domination, victimhood. In so doing, in trying to make such experiences explicit and visually immediate, I work largely against the tenor of contemporary visual art, which, while not directly denying such imagery, prefers to concentrate on other aspects of contemporary society and culture, often in very formal terms.

In setting this project up as a walk-through environment of images printed on large cibachrome and duraclear sheets—an experiential ground, a both generalized and specific terrain or location—the viewer experiences a range of contrasting scales of images at angular displacements that can have strong participatory implications. The enlargements of the images are gross, demanding, and can be voyeuristic but are also intimate and revelatory. In this installation images impinge upon images, aspects of the colliding media that we are so subject to today from film, photography, computers, and so on. No one can truly record or reinvoke the events that these images of resistance tell us of, but perhaps we can recognize the desperation and heroism and even perhaps the day-by-day aspects of the resistors, as well as their personal responses to the dauntless tasks they demanded of themselves.

History painting has had a difficult time in the twentieth century. Once a celebratory means of demonstrating the power and success of rulers and nations for the edification and pride of the population—for example, Assyria, classical Rome, the Renaissance, or French nationalist power in the eighteenth century—for the most part history painting succumbed to serious failings in the nineteenth century. For example, in France history painting became sentimental, vainglorious, flattering to all kinds of egotistical dramas of rulers. Modern art contemptuously rejected such self-conscious and vain purposes.

Nevertheless, given the history of the twentieth century and the fate of the Jews and others in Europe as well as current horrors, of course there are artists who attempt to come to a visual comprehension of these events and to record them as part of history and memory. Instead of conventionalized accounts and stereotypes, history painting can get under the skin of history and undercut conventional notions of what has occurred. The history of the twentieth century, its events and range, are extraordinarily documented through photography, film, records of all kinds. Photography and film are marvelous records and I have been powerfully influenced by them. Painting as historical record differs from film and photography and of course presents a very different physical and sensuous experience. Film is ever-changing, the viewer participates in a world of continuously variable imaging. Unlike film, painting is static. The image does not change and the viewer can remain in place in a contemplative mode as long as he or she desires. Film moves away from one; the viewer of a painting must move away from the object.

In *Partisans*, as in other installations I have done, I have shifted from painting and have entered the photographic/filmic world. It has become important for me that I can more or less simultaneously work both as a painter and through installations of filmic transparency. In *Partisans* there is the physical experience of walking through these images and the interpenetrations that they effect. One is in an image world, and image worlds are real worlds even as they are experienced symbolically or metaphorically—it's not so different from memory. In fact disorientation in scale, images at angular displacements, or disproportions of scale permit accessing experience from differing physical or mental locations.

The artist is a recorder of the state of civilization at the points of time the artist is present. All arts record the pulse of society. The artist is mirroring his or her society.

Partisans projects both a public scale and an intimate scale to insist on an interactive physical reminder that in that terrible time of the Holocaust those who could fought back.

LEON GOLUB is a politically engaged eyewitness to history who portrays and exposes the anguish of the human condition, an essential characteristic of his art. Working on often large, unstretched raw canvases, Golub has created paintings that powerfully depict situations of racism, oppression, and military conflict. An expressionist figurative artist recognized since the early 1950s, Golub took on an activist role in the 1960s at a time of domestic and international upheaval, responding with some of the strongest statements made in opposition to U.S. involvement in Vietnam. He has depicted the everyday evils of torture, terror, and the brutality of mercenaries. Referring to the Holocaust, the bombings of Hiroshima and Nagasaki, and the use of napalm in Vietnam, he produced the paintings of the BURNT MEN series. Golub often uses photographs as a source and reference for his paintings, and in recent years he has produced large-scale photo-based installations. In these walk-through environments viewers interact with transparent panels on which photographic images have been refocused, manipulated, and heightened.

A practicing artist for more than fifty years, Leon Golub is a member of the American Academy of Arts and Sciences. He has received honorary doctorates from the School of the Art Institute of Chicago (where he completed graduate and undergraduate studies in 1950), from Swarthmore College in Swarthmore, Pennsylvania, and the College of Saint Rose in Albany, New York. He has been the recipient of Guggenheim and Ford foundation fellowships, the Skowhegan Medal for Painting, the Dickinson College Arts Award, and the Visual Art Award from the National Foundation of Jewish Culture. In 1996 Golub and his wife, the artist Nancy Spero, received the Hiroshima Art Prize in Japan, and in 1998 jointly presented their work at the Festspielhaus Hellerau in Dresden.

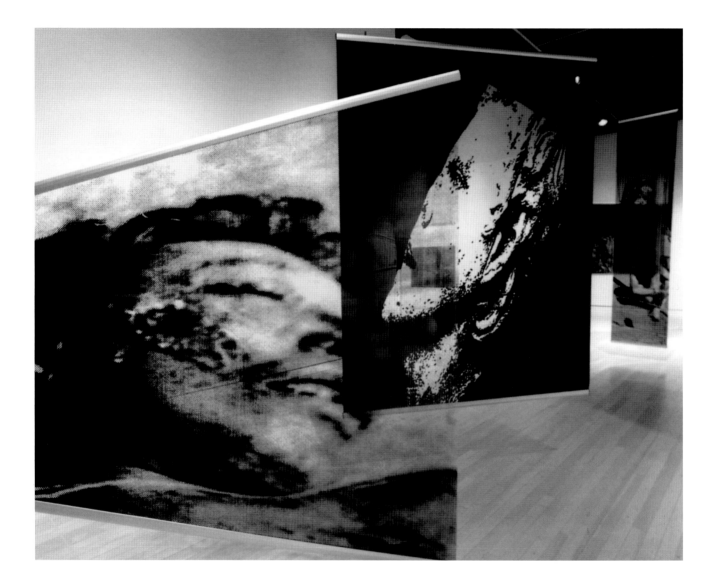

VIOLENCE REPORT, 1995. Photographic transparencies. Dimensions variable.

THE HISTORY OF THE TWENTIETH CENTURY, ITS EVENTS AND RANGE, ARE EXTRAORDINARILY DOCUMENTED THROUGH PHOTOGRAPHY, FILM, RECORDS OF ALL KINDS. PHOTOGRAPHY AND FILM ARE MARVELOUS RECORDS AND I HAVE BEEN POWERFULLY INFLUENCED BY THEM. PAINTING AS HISTORICAL RECORD DIFFERS FROM FILM AND PHOTOGRAPHY AND OF COURSE PRESENTS A VERY DIFFERENT PHYSICAL AND SENSUOUS EXPERIENCE.

Detail, PROMETHEUS II, 1998. Acrylic on linen. 119 x 97 in.

Most of Leon Golub's painting and installations have been concerned with public and political violence, covert actions, and the forces maintaining order and control in strife-ridden nations. His work has focused on mercenaries, political interrogation, Vietnam, the Holocaust, Hiroshima, and more recently, urban situations.

This installation deals with the activities of the JDC, which as a humanitarian organization operates in the public sphere. There are ten large-scale transparencies ranging in size from three to seven feet of Jewish partisan activity during World War II in Poland and Eastern Europe and includes images from occupied France. The project documents aspects of Jewish resistance in Nazi-occupied Europe. The source material is primarily from the United States Holocaust Memorial Museum.

Detail, PARTISANS.

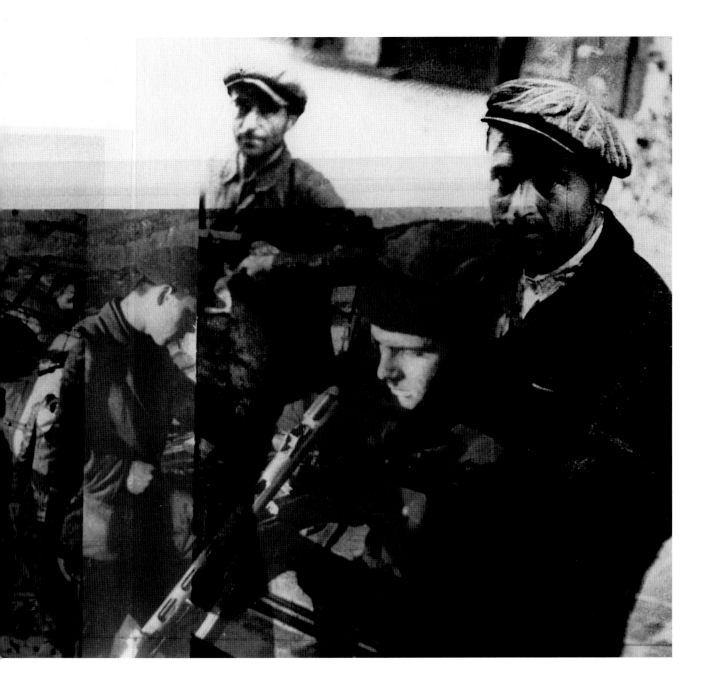

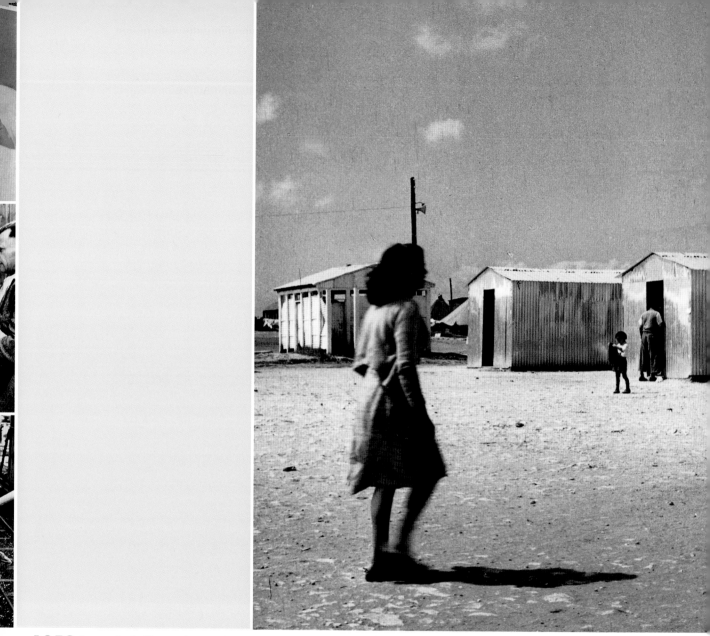

1950 As a result of cold war politics, JDC is expelled from the communist countries Romania, Poland, and Czechoslovakia.

1953 JDC is expelled from Hungary.

Malben set up shops in corrugated iron huts by providing owners with constructive loans. Beth Lid, Israel, 1951.

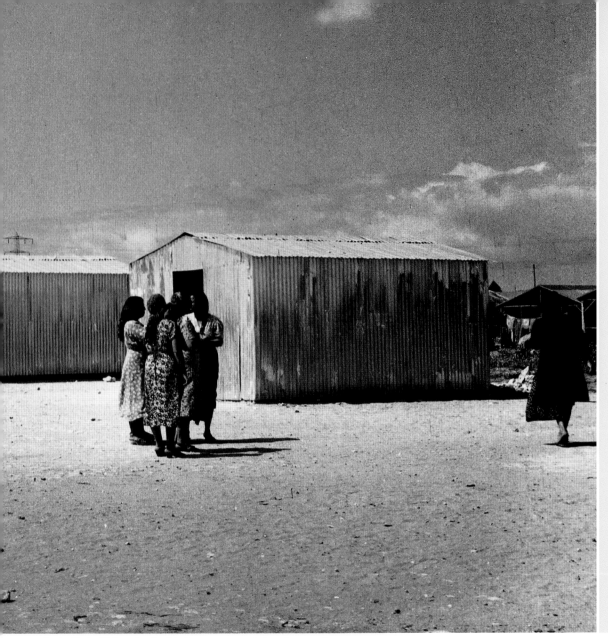

In the Soviet Union nine Jewish doctors are arrested on charges of plotting to kill Stalin and other top Soviet leaders. JDC is accused of complicity in the "Doctors' Plot" and is expelled from the USSR. (Three years later Khrushchev admits the false nature of the charge.)

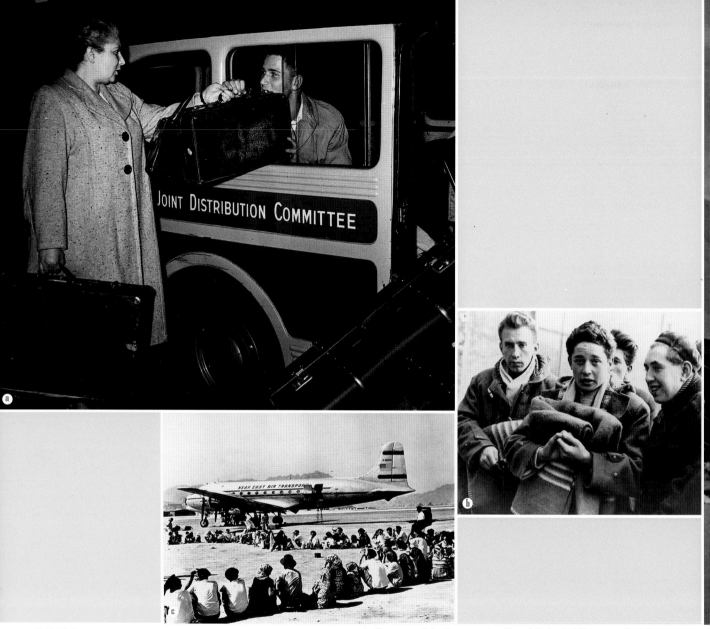

1954 JDC receives the first of eleven annual payments, totaling $77 million, from the Conference on Jewish Material Claims. Reparations will be used for the relief and rehabilitation of Nazi victims, mostly in Europe, and for the reconstruction of decimated European Jewish communities. In its role as the operating agency the JDC supervises all projects relating to relief.

a Preparing to relocate to Israel. France, 1950. b Hungarian refugees in Austria with blankets received from the JDC, 1956. c "Operation Magic Carpet," in which 46,000 Yemenite Jews were airlifted to Israel, c. 1950. d A playful moment at a transit camp in Cyprus, c. 1950.

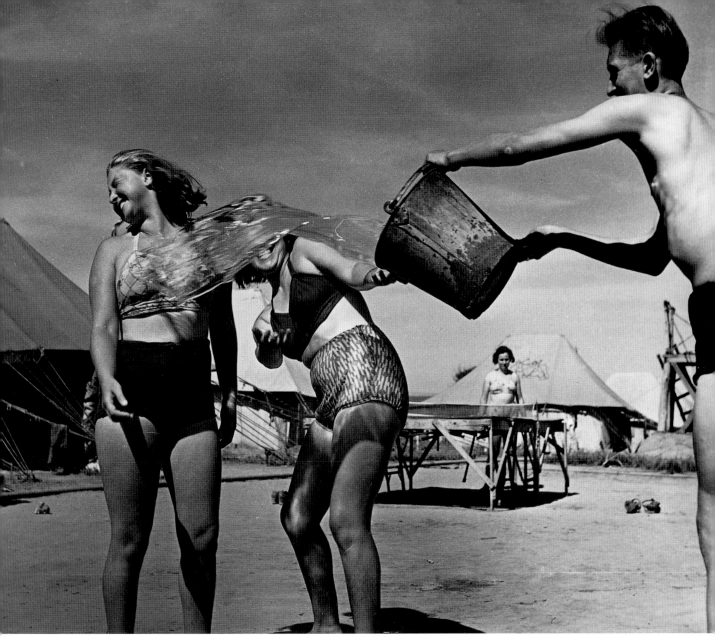

1956 Israel's Sinai campaign creates new waves of Jewish refugees from Egypt, who are aided by the JDC in France and Italy.

The failure of the Hungarian revolution sends Jews fleeing to Austria, where they receive aid through local Jewish organizations that receive JDC funds.

PEPÓN OSORIO

I'm interested in the humanity of the JDC's work, and the connection that exists between archive photographs that document the migration and the people in need, and the reality of who helps whom and how. The history of those activities is a collective consciousness, and brings forward the question of what is remembered and what is forgotten, about what is appearing and disappearing. You have to believe that magic exists in order to move forward. Like faith, magic is believing; it's the understanding that things happen and could happen and that they are somehow uncontrollable. And in that sense, the work of the JDC is magical, and it's through magic that I intend to interpret the archive as the embodiment of the people who believed in magic in order to survive.

I'm interested in connecting archival photographs that show what has happened in one country and what happened in another country, and looking for the patterns that connect them. The photography in the archive tells me what the circumstances and the issues of various communities were in the past and what they are now. We talk about the past, but when you look at photographs you realize the past was like yesterday. For me, the experience of working in an archive isn't so much about going back in history as it is about both being here in the present and witnessing the past, and acting in the past and looking at the present. It's important to see the connection between the way things were during the historic periods documented by the archive and where we are today in similar circumstances. My work takes place in the present and the past too. It's about creating a certain kind of experience that lets people look back on the things that brought them to the place they are now. I often use archival materials in my work to represent the past and the present at the same time in a way that brings both sides of the story to one place.

You look at the archive pictures and an amazing thing happens. You know

where the community was, you know where the community is, right now. You realize that you are looking at both circumstances simultaneously. You can't just say the past is the past. It's more about looking at both at the same time and having the opportunity to deal with the meaning of the event more so than the act of it. I think in that sense looking at photographs gives you the opportunity to negotiate history. You don't know whether what you're looking at happened then or if it's happening now. The sensation of the disappearance of time is important because we don't know exactly where we are. It's a challenging moment. It's about standing on the truth. It's about looking at and dealing with reality.

I think that people are scared. I think that we all are, and that experience brings with it a lot of discomfort and shame. Shame because of the past, of where we've been, and shame also because I think that we're in constant creation. We want to create a new way to redefine who we are, and these are very difficult desires to deal with. We are evolved, we are selfish, we are sweet, we are the combination of all the things that have led to certain moments in history. And that's what makes the whole notion of becoming more conscious important, the whole notion of people becoming more responsible, becoming more human and improving their condition rather than just repeating their condition. I'm trying to be optimistic about this; implicit in civilization's understanding of history is that there is a better method of how we engage in the experience of life and how we look at each other.

That's part of the circumstance of being an artist in the late twentieth century and experiencing the historical crises of our time. Art is not separate from the crises, and I feel that as artists we are not alone, we are many in one, that's part of our role as artists. There's a part of me that is what I do in everyday life, and then there is also who I am as an artist, but I don't see them as separate issues. This is the human part that I find to be important, dealing with social issues, cooperating with others and becoming an activist and dealing with the events of everyday life. It's also my sense of understanding that when people come together somehow things change, things happen, and I see that in my work as well. Artists can change the discourse of art and shift the experience and the discussion about art from institutions out into other places and communities. The discussions artists have have always been about art, but in order to make and look at art we have to look at ourselves as part of the whole, not as separate and alone. As artists we cannot disassociate ourselves from human experience. Our work is more about emphasizing experience, bringing it in, combining it into our work, and going forward.

When I was working in the archive I looked at pictures of people coming

PEPÓN OSORIO is known for interdisciplinary work combining art and nonart techniques to explore culture, community dynamics, and to expose stereotypes. Since 1985 he has concentrated on creating installations that depict the experience of his adopted community, the South Bronx, and in 1991 his work was the subject of a retrospective at El Museo del Barrio in New York. Major works include: THE SCENE OF THE CRIME (WHOSE CRIME?), exhibited at the 1993 Whitney Biennial; EN LA BARBERIA NO SE LLORA (NO CRYING IN THE BARBERSHOP), a work that explores the pervasive role of machismo in Latino culture commissioned by Real Art Ways that opened in Hartford in July 1994; BADGE OF HONOR, a video installation about a young man growing up in the absence of his jailed father; EL CAB, a mobile installation placed in independent taxicabs in New York City; and LAS TWINES, a video installation exploring race in the Puerto Rican community of the South Bronx. Osorio's works are filled with real-life objects and create worlds that are striking for their humanity, theatricality, and exuberance. Originally from Puerto Rico, Osorio has made his home in the South Bronx since 1975.

Pepón Osorio has received grants, commissions, and awards from the National Endowment for the Arts, the New York State Council on the Arts, and the New York Foundation for the Arts. He was awarded a media fellowship from the Rockefeller Foundation and has won the Louis Comfort Biennial Award, the New York Dance and Performance BESSIE Award, and the 1996 International Association of Art Critics Award. His work is represented in major collections across the United States, including those at the Whitney Museum of American Art, El Museo del Barrio, the National Museum of American Art, the Walker Arts Center, and Wadsworth Atheneum.

together, a lot of people sitting around places. I saw a sense of community in their faces, and I knew what the bad circumstances were like, but I also knew that it was going to get better. I look at photographs of people who by providing relief intend to make things better, and I sense that there is a formula that they use. There is a way of getting through these challenges, and they do get through. That for me is magic, and everybody's got magic in them. We just have to figure out what it is. For me that's more of a holistic process than anything else, a bringing together of all the elements. When I work with the archives I'm not only bringing art to that process, I'm also bringing a sense of collective consciousness, a sense of community, a sense of cooperation, a sense of spirituality. And all of these things coming together and making magic. If I only see this work that I do independent from everything else, it doesn't work.

I'm stuck with this belief because every time I hear the word *human*, I hear the word *inhuman*. You're human when you bring together all these different elements that I've been talking about. The spirituality, the physical, the emotional, all these different positive qualities that are within us. When one of those elements is not around, then you're inhuman. That's what I'm trying to talk about, trying to say in the work: you're inhuman when any of those qualities is missing from the whole being. Those elements are missing in major disasters or in time of war. When one of those elements is not working it becomes

IT'S IMPORTANT TO SEE THE CONNECTION BETWEEN THE WAY THINGS
WERE DURING THE HISTORIC PERIODS DOCUMENTED BY THE ARCHIVE
AND WHERE WE ARE TODAY IN SIMILAR CIRCUMSTANCES. MY WORK
TAKES PLACE IN THE PRESENT AND THE PAST TOO. IT'S ABOUT CREAT-
ING A CERTAIN KIND OF EXPERIENCE THAT LETS PEOPLE LOOK BACK
ON THE THINGS THAT BROUGHT THEM TO THE PLACE THEY ARE NOW.

very hard to reach the human condition; you're not living in harmony. I'm looking for that harmony in the work that I do.

This also explains why in my work there's often the appearance of excess, because I operate on the principle that the more you bring into the journey, the better. This abundance in my work, the excess, comes from the fear of not having, the fear of lacking, the fear of being in want. It is the fear of a colonized person, and class therefore is also an

extremely important element in my work, as is history. My parents experienced World War II, and they experienced the possibility of not having an end to the Depression, and I understand those feelings. So in my work I sometimes emphasize to the point of abundance as a way of avoiding this emptiness, scarcity, and lack. It's about possibility and optimism, but at the same time it's a means of self-protection. You become inhuman if you do not have enough, if you do not have enough food. If you do not have enough warmth, or sleep, you can turn into an animal.

But I am also very much aware of the need to transform, the need to create abundance where it doesn't exist. I'm aware of the need to challenge our notion of what material goods are all about, and the exaggerated aspect of my work, the excess, addresses this belief too. I realize that this provokes strong reactions and makes some people uncomfortable, and I think that some people look at the work as obsessive. But it isn't an obsession; it's about dealing with this lack of things, the failed economies, and I think that the experience people have of my work, how they interpret it, depends on where they look at it and how they look at it, what their own histories are, what the images from their past are, and where they're coming from. I'm putting them into a circumstance that they're not used to and asking them to feel the magic that's so essential in all our lives.

Details, BADGE OF HONOR, 1995. Mixed media and video installation.

In this work magic is seen as a metaphor for survival and as a means of understanding humanity and history. There is a kind of magic in the work of the JDC, and the evidence of that magic can be found in its archive—records of activities that inspire a strong sense of wonder. They are filled with accounts of people who have found extraordinary creative solutions in order to survive extreme adversity. The focus of this project is on the wonder of these people's magical acts of survival.

The project consists of a video installation derived from archival material in seven magical acts of appearance and disappearance, developed in collaboration with a magician, and incorporating historical information about various communities. In the research phase of project development people were interviewed about their relationship to magic in the world, with some emphasis on the four elements—fire, earth, air, and water—and their relationship to populations that have been affected by natural disasters, floods, fires, and earthquakes.

Photography-based archival material is presented through the magic of video in various ways. Several monitors are placed on separate tables. Each table is covered with a cloth of red velvet embroidered in gold with the names of the acts: Act One, Act Two, and so on. Each table displays paraphernalia relating to the archives and to magic acts, as, for example, a deck of cards printed with JDC photographs or a magnifying glass. Video loops feature the magician's white-gloved hands manipulating photographic images, making them appear and disappear as if with a veil or the wave of a wand. Like the JDC archive itself, there is only the ambient sound of the gallery, and the room is not dark.

Study for JDC installation.

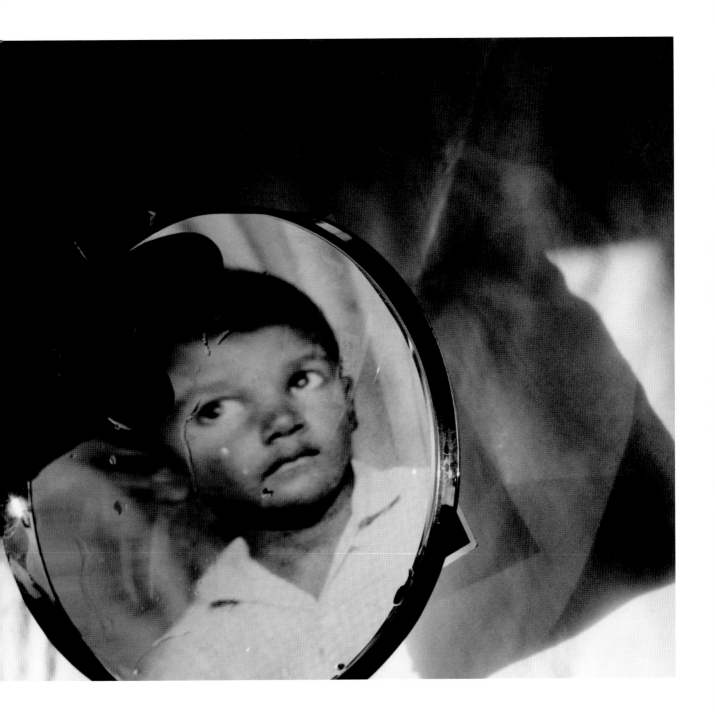

1962 Algeria becomes an independent state and 100,000 Algerian Jews—roughly 90 percent of the Jewish population—arrive in France in a four-month period to escape rising Arab nationalism and a deteriorating economy. JDC helps both the refugees and the French Jewish community to cope with these dislocations.

a Volunteers in Marseilles aid in the arrival of elderly and disabled Algerian refugees, 1962. b Iran, 1965. The United States government donated "food for peace" supplies, which were distributed by the JDC in Iran.

In India the JDC begins helping the Bene Israel Jews restore their Jewish life and community by developing religious and cultural programs. Jews have always lived free of persecution in India, but their small number and isolation had made it difficult for them to establish themselves as a community.

c Torah scrolls spread out to dry after floods in Florence, 1966.

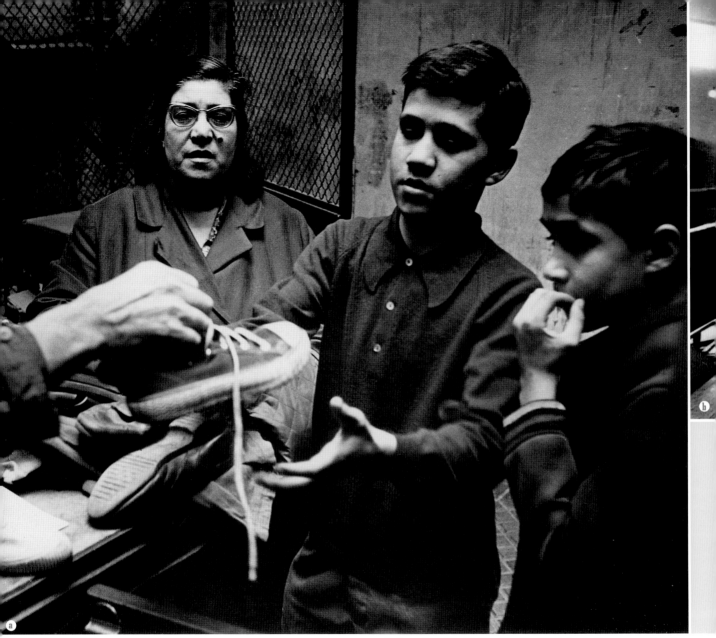

1967 The JDC is invited back to Romania to help provide services to its aging Jewish population.

In the wake of the Six-Day War the JDC helps in the mass exodus of Jews from North Africa and Moslem countries in the Middle East.

a Local Jewish welfare agencies supported by the JDC provide warm clothing and shoes to newcomers from North Africa. Paris, 1966. b A rabbi and two students survey the damage to the study hall at the Yeshiva Beth Joseph after a three-day bombing during the Israel-Arab war. Jerusalem, 1967.

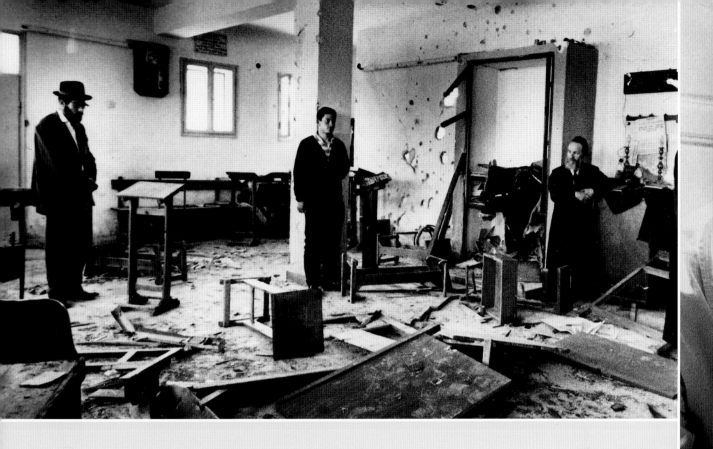

Charles Jordan, executive director of the JDC, is murdered in Prague.
The case is still being investigated.

GILLES PERESS

Since the fall of the Berlin Wall in 1989 I have worked on issues and projects that deal with the notion of difference/similitude. I have focused on historical moments where one group decides to break the social contract with another group and see the other as radically different. Having previously published *Farewell to Bosnia* and *The Graves,* I am in the process of finishing a third book on the former Yugoslavia. During this period of time I published *The Silence,* a book about genocide in Rwanda in 1994. I have just finished the last chapter of a project on Northern Ireland.

The main goal of these projects is for me to understand—as a witness and as a citizen—the historical period to which I belong. I am essentially doing these projects because I do not trust the media (even though I have worked with it for many years), because I have been forever suspicious of words, and because it is an issue of moral survival to deal in real time with real historical situations. Can we deal with history?

In letters published in *Farewell to Bosnia* I outlined my perception of the curse of history. These letters explain better than anything I can say now why I do what I do.

From a letter to Philip Brookman:

I think I am unwell, and I don't know if I alone have caught the virus. I have a peculiar disease that has to do with time and history. I call it the curse of history, and it has to do with the fugitive absence/presence of personal and collective memory. The flashbacks started in a hospital room in Tuzla, filled with legless, armless men, all grimacing in pain. I remember my father, his amputated arm and his pain, his descriptions of addiction to morphine, of World War II, the German occupation, and the concentration camps. A flow of buried images started to come back to me. . . .

I began to think that I had come to Bosnia in part to see, almost to relive

visions buried in my childhood memories. This flow started to submerge me and, like a tidal wave, it pushed through to my consciousness that the Yugoslavs (Croats, Serbs, Bosnians) must also be going through the same experience. Fathers telling horror stories from the war. Mental images so horrific that one is compelled to actually "see" them to deal with them. And to see them, you have to act them out.

Here starts the curse of history that may not be so personal anymore. It may be a very European disease with a double-edged nature: you are damned if you remember—condemned to relive, re-enact the images of your fathers; you are damned if you don't—condemned to repeat their hypocrisy.

From a letter to François Hers:

I am finishing the last pages, cutting . . . pictures of memberless bodies. Reconstructing experience. Unable to focus, to edit. Talking to myself—in the shower, eating, walking—my head fills with stillborn words, silent screams. . . .

I remember my mother, who, upon learning I was going to Bosnia, said, "But my darling, why? Why? Why are you going there?"

"Well, Mother, there is a civil war . . . important . . . end of a nation. . . ."

"But mon cheri, we have terrible memories of these people. During the war the Croats, I mean the Ustashis, were on the side of the Boches (Germans). They massacred everybody, especially the Partisans. Then Tito massacred them. He even massacred his own people. You know, my darling, those people, they are not our kind of people (ils ne sont pas fréquentables). They massacre each other and then we have to come in and we have to pay. It is insufferable (c'est insupportable)!"

From a letter to Walter Keller:

It's Munich all over again. We, the Europeans, are floating in the vomit of our own past, refusing to confront our responsibility for non-intervention. We are caught in a time warp . . . with the ghosts of Spain, Poland, Czechoslovakia, the Warsaw Ghetto, swirling around in a whisper: "Remember us? You fools?" . . .

We are worse criminals than the Serbs. We are the ones who do nothing. Buying back our good conscience by feeding the condemned Bosnians in the hour before their death. Failing to understand that 200,000 deaths later, their battle to maintain the integrity of a multicultural nation was ours. Now, no matter what, even if we use air strikes, it is too late! Bosnia will be dismembered. Rapes and mutilations will go unpunished. Aggression will be rewarded. Meanwhile, we, too, will have lost some essential parts of ourselves."

GILLES PERESS was born in France in 1946 and attended the Institut d'Etudes Politiques and the Université de Vincennes. He began working as a photographer in 1970 with a portrayal of a French coal mining village struggling to rebuild itself after a debilitating labor dispute. In 1972 he joined Magnum Photos as an associate and became a member in 1974. In 1971 Peress traveled to Northern Ireland to begin what has now become a twenty-seven-year look at the Irish conflict. POWER IN THE BLOOD, which formalizes his work there, is the fourth part of HATE THY BROTHER, his series of documentary books and exhibition projects that witness intolerance and the reemergence of nationalism in postwar years. THE SILENCE, a book about the genocide in Rwanda, FAREWELL TO BOSNA, and THE GRAVES: SREBRENICA AND VUKOVAR are cycles in the series. In 1979 Peress traveled to Iran to document the fragile relationship between American and Iranian cultures during the Iranian revolution and compiled

his commentary in TELEX IRAN: IN THE NAME OF REVOLUTION. Peress's other major projects include understanding the flows of immigration throughout Europe, and an examination of the legacy of the Latin American liberator Simon Bolivar. Peress has lived in New York City since 1976.

Peress is the recipient of many awards, including fellowships from the Guggenheim Foundation, la Fondation de France, and the National Endowment for the Arts. He also received the W. Eugene Smith Award for Humanistic Photography. His work is exhibited in museums and galleries throughout the world, and his photographs are in the collections of, among others, the Metropolitan Museum of Art, the Whitney Museum, and the Museum of Modern Art in New York, the Musée d'Art Moderne in Paris, and the Victoria and Albert Museum in London.

It's five years later. Nothing has changed and some things have changed. Nothing has changed in the sense that Kosovo is happening and we are again doing very, very little about it. Something has changed in the sense that in 1997 in Rome a permanent war crimes tribunal was created and Pinochet was arrested in London. So that we are in a tension between the speed of history—which happens very, very fast—and progress, which happens very, very slowly.

History occurs in a fairly haphazard way, borne out of human nature, which is very much about half-baked ideas, and very often wrong half-baked ideas that succeed because of our inherent passivity or inability to contradict, intervene, or react in real time.

Progress—or at least our perception of progress because it is measured in our lifetime—seems always infinitesimal and agonizingly slow. It is affected by our fundamental lack of courage and moral determination. However, in the middle of the despair I, if not we, have to come to terms with the monumental job that we are confronting as historical beings. At the end of this millennium we have barely managed in some parts of the world to establish civil societies within countries; we are barely emerging out of the notion of the supremacy and sovereignty of the nation-state. Maybe we have to reconcile that it may take two or three generations before true human rights are established, before individuals are guaranteed protection against the abuse of the sovereign, the abuse of the state, or any group who takes the law or the absence of it into its own hands.

The privilege of having access to the JDC archive was for me a way of travel-

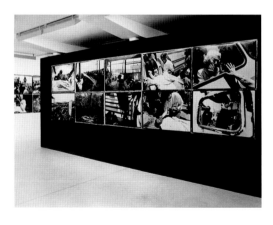

FAREWELL TO BOSNIA, 1994. Installed at the Fotomuseum, Winterthur, Switzerland.

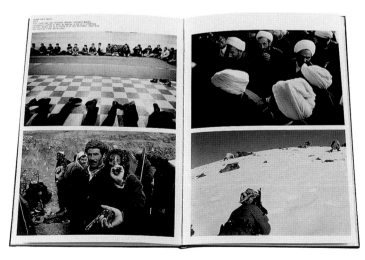

From TELEX IRAN: IN THE NAME OF REVOLUTION, 1984.

ing through images to a period I could not be a witness to. It has been a process of learning about history while reformulating questions that intrigue me always. I come from a mixed immigrant family that settled in France more or less at the time that the JDC was created and that decided to stay in France during World War II. Our family, like others, believed that it had assimilated. Like in Poland, Russia, or Germany, all kinds of warning signals were drifting through the consciousness of daily life. I am intrigued by the belief of some individuals that they were so well inserted in their respective societies that they would be safe because they had good German friends or because they were good French citizens. It is that blindness to the historical process, the inability to read the signs before history rolls on, the existence of those signs as well as of the pattern of previous persecution that made the experience of this archive so rich for me.

And of course, there is photography. As an image maker I have always had the attitude that there was a multiplicity of authors to the image. I was extremely intrigued in a reversal of perception. In any given image there are at least four authors: the photographer, the camera (each camera describing reality in a unique way), reality itself that speaks with a vengeance, and finally, the person who is reading the image.

As a reader of the images in the JDC archive I became aware not only of the depiction of the events in the photographs—not only of "what the world looked like in these pictures," to paraphrase the photographer Garry Winogrand—but I also began to feel and hear these images as speaking objects. Images/objects that are about time, that have aged

IN ANY GIVEN IMAGE THERE ARE AT LEAST FOUR AUTHORS: THE PHOTOGRAPHER, THE CAMERA (EACH CAMERA DESCRIBING REALITY IN A UNIQUE WAY), REALITY ITSELF THAT SPEAKS WITH A VENGEANCE, AND FINALLY, THE PERSON WHO IS READING THE IMAGE.

and weathered to acquire the pathetic beauty of lessons learned from history. It is a bit like when really old people tell you about their lives, tell you about dramatic things that happened to them, the tragic moments. In their stories there is a certain fondness for the pathetic beauty of such moments because, after all, it's the only life that they've ever lived.

Borne out of the urgency of tragedy and transformed by rot, laden by the dust of time, these objects enlightened me about meanings different from my own images.

This project, which draws on the concepts of Album/Memory/Fear/Family/History and Archive, focuses primarily on archival documents from World War I to 1947. Among a vast number of historical materials the JDC archive contains photo albums of differing shapes and sizes, suggesting to Peress the form of a large-scale book, an ALBLUM OF FEARS.

This book of 100 pages when opened to a double-page spread is 28" x 70", a scale reminiscent of medieval manuscripts. The project investigates historical facts and fears that should have been at the root of a survival instinct in subsequent years. The 250 or so images contained in this book are digitally produced by scanning pictures and artifacts, then printing them on a wide-format printer using archival inks and paper.

The book consists of three chapters, or acts. The first chapter, "The Forgotten Land," deals with a sequence of JDC folders about pogroms in what is now a truly "forgotten land," as well as in Poland and Russia, and with the creation of orphanages as places of refuge.

The second chapter, "Itinerary of Fear," deals with the years preceding World War II and examines the imminence of catastrophe, as we see the development of anti-Semitic propaganda and memorabilia in Europe. For example, the spread of this fervor is captured in a small album compiled by a Dutch motorcyclist, who traveled from the Dutch border to Berlin documenting various anti-Semitic signs posted along the road and in storefronts.

The third chapter, "The Dread," is about the first glimpses of what happened to those who, because they were confident about their assimilation in society, did not follow their "instinct" and act on warning signals. It contains, among other things, the contents of one envelope sent to the JDC shortly after the liberation of France, documenting a war crime in which victims had been dumped into a French provincial well.

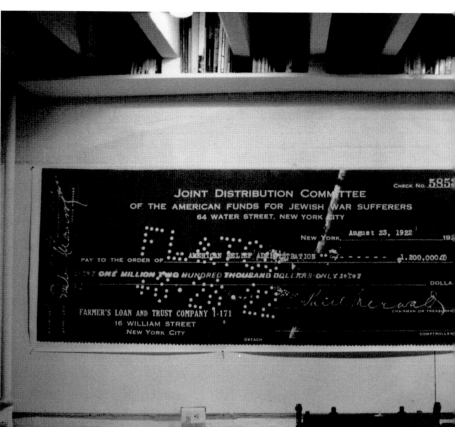

Study for ALBUM OF FEARS.

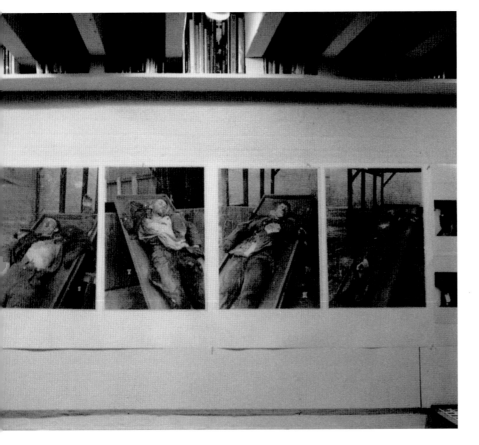

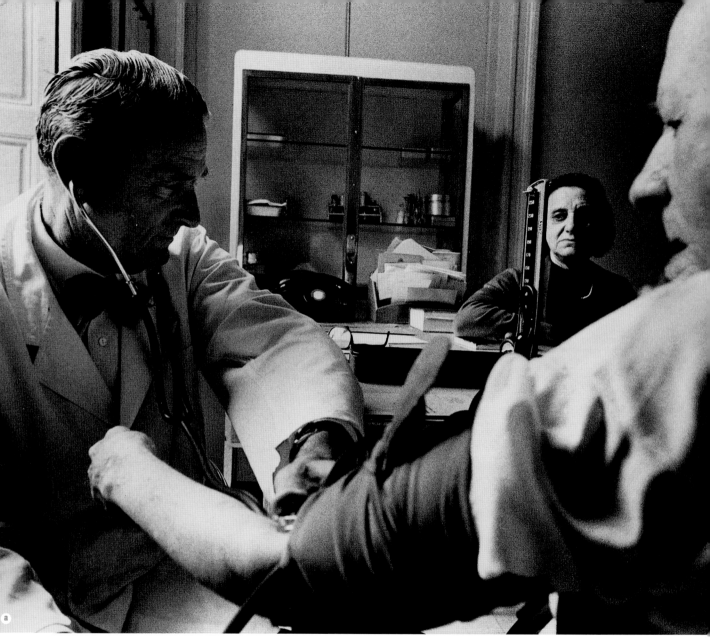

1973 JDC expenditures since 1914 surpass $1 billion.

1975 In Israel the population of those age 65 and over has more than doubled between 1948 and 1975. To meet the needs of this group JDC joins the government of Israel and the Ramapo Trust to establish the Brookdale Institute of Gerontology and Adult Human Development in

a At an OSE (Oeuvres de Secours aux Enfants) gerontological clinic in France, 1972. The JDC provides financial assistance to the OSE, which cares for 6,000 people.

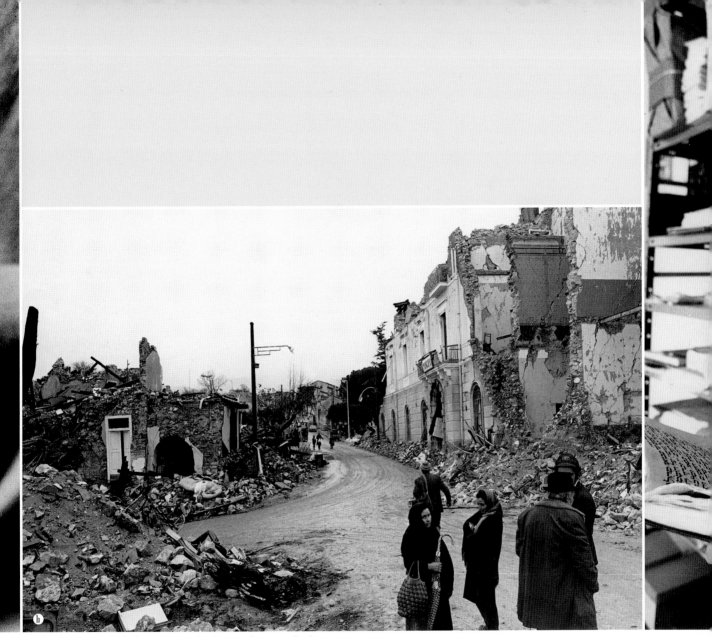

Israel. The Institute includes an international center for research, planning, and education in the field of aging.

1977 In Ladispoli, Italy, JDC begins providing help to Soviet refugees fleeing persecution.

ᖯ Laviano, Italy, after an earthquake, 1976. The JDC provided aid to residents of the devastated town.

1978 JDC joins Catholic Relief Services and the Church World Service to establish the Interfaith Hunger Appeal. The program attempts to focus American attention on the issue of world hunger.

1979 Jewish emigration from the Soviet Union peaks at 51,663. JDC organizes religious and cultural programming for those waiting in Austria and Italy for visas to the United States, Canada, and other western countries. It also provides them with relief and welfare services,

a Young Russian newcomer in Israel, 1973. b A social worker prepares an elderly woman for a move to a new home, a modern apartment that she will share with other elderly citizens. Morocco, 1971.

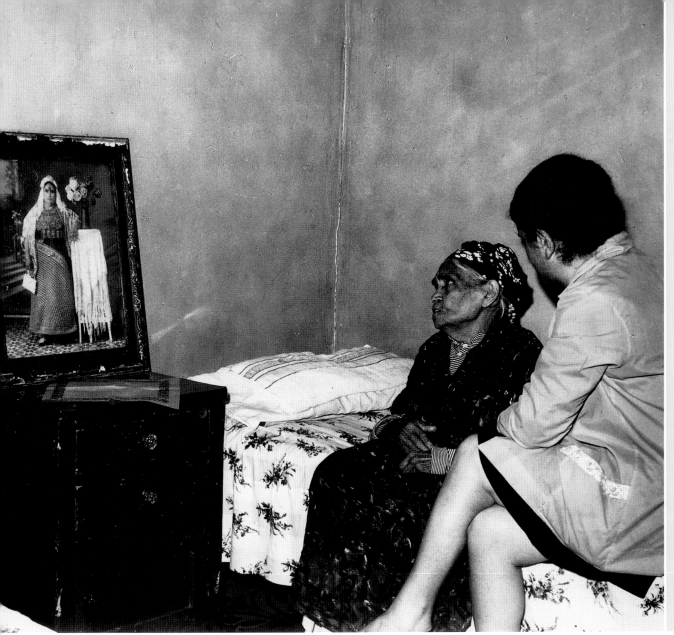

90 percent of which are later reimbursed by the United States Refugee Program.

Starving Cambodian refugees arrive at the Cambodia–Thailand border in November and December. JDC, in behalf of the American Jews, contributes to the emergency feeding programs, and by year's end receives $150,000 in donations.

FRED WILSON

I'm a visual person. I respond to the visual world, but I'm not interested in making art from raw material. I feel there are so many human-made and natural things in the world that are misrepresented, misunderstood, or compromised that I'd rather respond to that idea—through the reordering, relooking, and recontextualizing of objects and images—than creating something new from scratch. I've tried to distill meaning out of the archive; I feel this is my role in this project. I wanted to see what has been done to the images in it, to consider where and why the photographs were taken and where they've gone, so that eventually I can comprehend these photographs as the building blocks that created this world.

When creating my work, I open myself up to respond to things in the world physically and I pay close attention. That physical response is who I really am; the intellectual is who I've become. I believe the physical response, the emotional one, can tell us more about ourselves because it is more immediate, unexpected, and less controlled—especially if you've been caught off guard. Our intellect kicks in soon after to tell us the proper, socially acceptable response. The physical response is much more intriguing than the intellectual response: I know what this is. They're not comfortable experiences. I mean, who wants discomfort in their lives? The human thing may be to not look back, to keep moving forward, to move forward just to survive. But I have a hard time doing that. I want to know, Why am I the way I am? Why are people the way they are? Why is the world the way it is? Why do I feel uncomfortable about certain things and other people don't? Why are they ignoring their discomfort? This is how I exist in the world, and I have chosen to focus on these questions in the art I make.

When I work, I assume I don't know anything about anybody. As a basic

humanist, that's where I start. If you don't put on me that you know who I am, then I won't put that assumption on you. I'm not looking for a particular sign or goal post; my work is a kind of personal meandering. The difficult thing is to keep from getting on a well-worn track or to keep people from pushing me onto a well-worn track. That's the difficult part. The meandering is the part that I enjoy, the part that comes naturally, and it is essential to learning anything new or getting to someplace new.

This project is different because it's very defined. My first experience of the JDC archive was one of frustration, as I realized its vastness, looking at the images and experiencing the physical, overwhelming nature of the archive. I realized I could never really know the whole thing. But the frustration of the vastness is interesting to me. It's more opportunity. I can just continue and continue.

We're always bombarded with images of some kind. We choose them arbitrarily and we assign meanings to them and live through them, and then eventually we decide that they are reality. I try to sit with that knowledge and not let it go, because it's a frightening thought that's hard to get outside of. We're not even necessarily talking about original experience. With the archive photographs I tried not to get involved with the specificity of the information: who the child was, where he came from, how he was fed. Instead I became interested in these secrets the archive held that I would never really know. This is not unlike other situations in life, and it struck me that was what my piece was going to be about.

I am reducing each photograph to some aspect of the image that may or may not be the essential point of the picture, and it may not be why the JDC kept the picture. It doesn't really matter how I pick the photographs. If the archive were the history of the world, if it were even broader, I might feel less confident. It does matter that there were different kinds of photographs in the archives, and for each of the categories there were images that interested me. Choosing them was not necessarily emotional, although emotional pictures were part of my choice. I responded. There's not a banal picture that I didn't have a response to. There's probably a picture that I wasn't necessarily interested in, but there was *something* in the picture that jumped out at me, that intrigued me. It was this combination of things.

I've obscured the content of most of each photograph, except for the one point that interested me. Whatever was hidden is the real story. Maybe it's the whole story. I want the experience of looking to be completely frustrating. The viewer is forced to look at the point of interest, because there's nothing else there. I am recreating the kind of frustra-

FRED WILSON, maker of provocative installations, poses unconventional questions about the motivations of museums and cultural institutions, drawing on his understanding of cultural history and his personal experiences as an African American of mixed ancestry. Early in his career Wilson worked as an educator in New York City museums, where he became interested in the philosophy and intention behind a museum's mission. By the late 1980s he was using his insider knowledge to create a series of installations about museum practices, exploring how and why objects are selected for display or placed in storage and what those choices tell the public about an institution's priorities. His widely known project MINING THE MUSEUM (1992) for the Maryland Historical Society, Baltimore, considered the judgment and cultural assumptions of museum professionals as they determine how cultural history is constructed and displayed for diverse audiences. Wilson recently collaborated with the Egyptology Department at the British Museum, using borrowed artifacts and antique cases and labels to examine the underlying issues behind the museum's involvement with Egyptian cultural history.

Fred Wilson has presented solo exhibitions at the Indianapolis Museum of Art, the Seattle Art Museum, and the Museum of Contemporary Art in Chicago, and has had numerous gallery exhibitions since 1991. His work is in the collections of the Baltimore Museum of Art, Whitney Museum of American Art in New York, Seattle Art Museum, Denver Art Museum, Kresge Art Museum at Michigan State University, and the New School for Social Research in New York. A graduate of the State University of New York at Purchase, Wilson is a recipient of grants from the New York State Council on the Arts, the New York Foundation for the Arts, and the National Endowment for the Arts. Wilson's award-winning Baltimore project was jointly sponsored by the city's Museum of Contemporary Art.

tion that I had with the archive, never being able to truly know this archive, and what it represents. What was interesting for me in experiencing the archive in this way is that it really was very much how we experience the world. By transferring that experience of frustration, by making people focus on our inability to know, perhaps they might focus on the larger issues physically or emotionally—not only intellectually. It becomes a question of what else is there: If there is one of these, what else is there, and how much?

The larger, more important question is how other people control our view of the world, recognizing the vastness of information and how we're fed certain small aspects of it, and how we can be lulled into being comfortable with just that bit of information.

THE LARGER, MORE IMPORTANT QUESTION IS HOW OTHER PEOPLE CONTROL OUR VIEW OF THE WORLD, RECOGNIZING THE VASTNESS OF INFORMATION AND HOW WE'RE FED CERTAIN SMALL ASPECTS OF IT, AND HOW WE CAN BE LULLED INTO BEING COMFORTABLE WITH JUST THAT BIT OF INFORMATION. THAT'S OUR EXPERIENCE IN THE WORLD.

That's our experience in the world. There are certain things that we already know. I'm trying to make people question the known quantities. The question is, Where can I go with this? And one hope is that in this questioning they ask themselves out loud: "How come I've only seen part of the picture?" Somebody will say: "Because I'm only seeing part of the picture." And that turns into self-questioning. So it's about being a little more awake, and allowing yourself to be even a little more awake.

I can't say that I started out as an artist thinking that I could change the world. Artists are very self-centered and I think we do our best work that way, because we're touching something deep in ourselves. And somehow because we're touching something very essential, we touch other people. What's essential for me are these experiences. I can't get away from it. Sometimes I try to make art that's nonobjective and completely abstract, but it just has no meaning for me. I always come back to something that's somehow culturally mediated, because it's where I live. I can't not do it.

(Top) Detail, MINING THE MUSEUM, 1992. *(Bottom)* MINE/YOURS, 1995. 11 x 24 x 11 in.

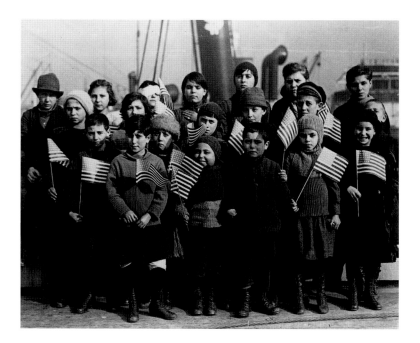

In seeking to mimic the mass and meaning of the JDC's collection of photographs, Wilson uses the archive itself as the sole material and subject for his artwork. For Wilson the futility and frustration of not being able to fully understand every image is heightened by the knowledge that this archive contains some of the most horrific—and hopeful— images recorded in this century. Wilson views this project as a metaphor for the difficulty in grasping life's magnitude and its innumerable events. Through this project the artist asks, How much do we selectively choose to know? How much is selec-tively chosen for us to know by others? How much is humanly possible to know at any one time?

The installation consists of three adjoining walls. On the first wall framed photographs are paired with photographs matted to block out all but a small portion of the image. It is clear from the pairings, however, that the unmatted photograph is the same as the matted one, which has been rendered incomprehensible. These juxtaposed photographs are the key to understanding the balance of the installation.

As with the first wall, the second is covered with

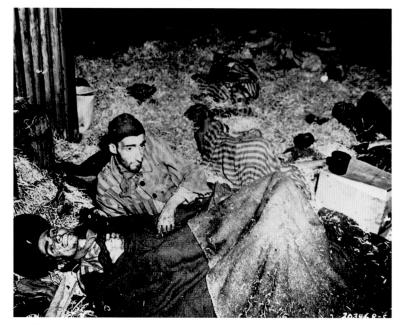

Studies for JDC installation.

a grid of framed photographs, each matted to reveal only a tiny portion of the image. In this space, however, no pairings reveal what the source photograph is. The viewer is left with only small, abstract visual clues and doubts as to their meanings.

If the first two walls provide the viewer with a range of experiences and emotions, the third wall provokes meaning and imagination without specifically explaining these images individually. Attached to the wall is a shelf containing photocopies of pages from the archive's ledger books that describe in words the photographs from which the matted images were culled. No specific connections are made between individual photographs on the wall and written entries on the archive's pages, and there are many more entries than photographs. Any relation between the often evocative written entries and enigmatic bits of photographic images are left up to the viewer. The quest for knowledge is thereby limited only by one's curiosity and imagination; it is sobering to become aware that such knowledge is not easily gained.

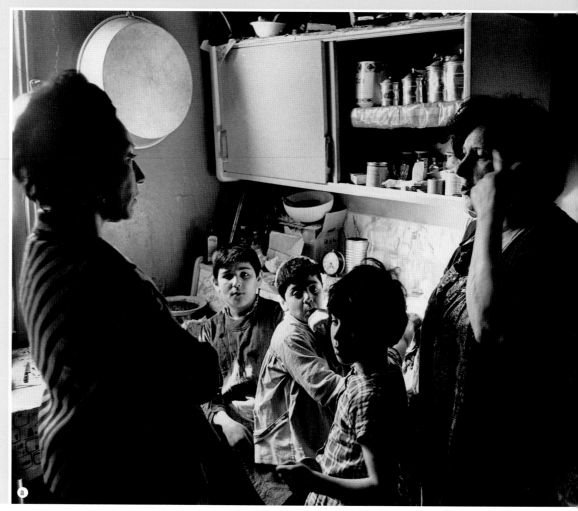

1980 JDC is allowed to return to Hungary to provide services to 80,000 to 100,000 Jews—the largest remaining Jewish community in Eastern Europe.

In April JDC begins to participate in the Educational Program at the Khao I Dang holding center in Thailand, sponsored by the United Nations High Commissioner for Refugees.

JDC launches Open Mailbox campaigns to channel nonsectarian aid to victims of catastrophic events around the world.

a A Tunisian family in Paris, 1981.

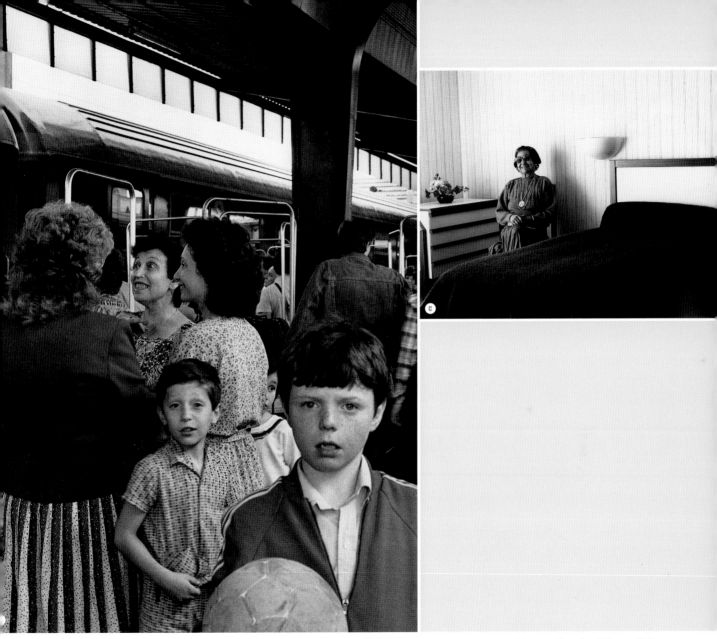

1981 After more than forty years the Polish government allows JDC to provide food, welfare, and Jewish cultural enrichment programs for nearly 6,000 individuals.

1982 Following the peace accord between Israel and Egypt, JDC receives authorization to operate in Egypt.

ʰ Families transmigrating from Vienna. Italy, 1989. ᶜ France, 1983.

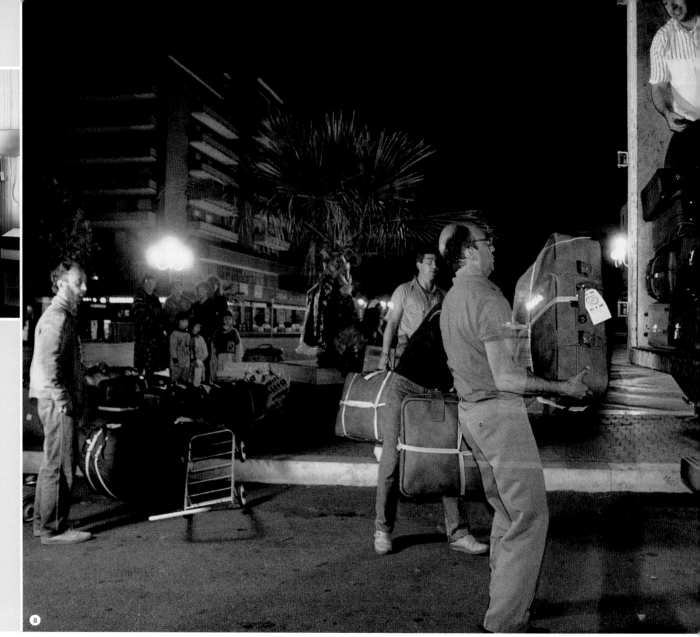

1983 After prolonged negotiations communication is established with Ethiopia. JDC ships $500,000 worth of clothing, cloth, medical, and other supplies to Ethiopians, and in response to the famine negotiates a nonsectarian relief and agricultural recovery program in the country.

1986 JDC launches its International Development Program (IDP) to aid in the recovery and rehabilitation of local populations after natural or man-made disasters.

a Going to Rome airport for a final departure to America. Ladispoli, 1989.

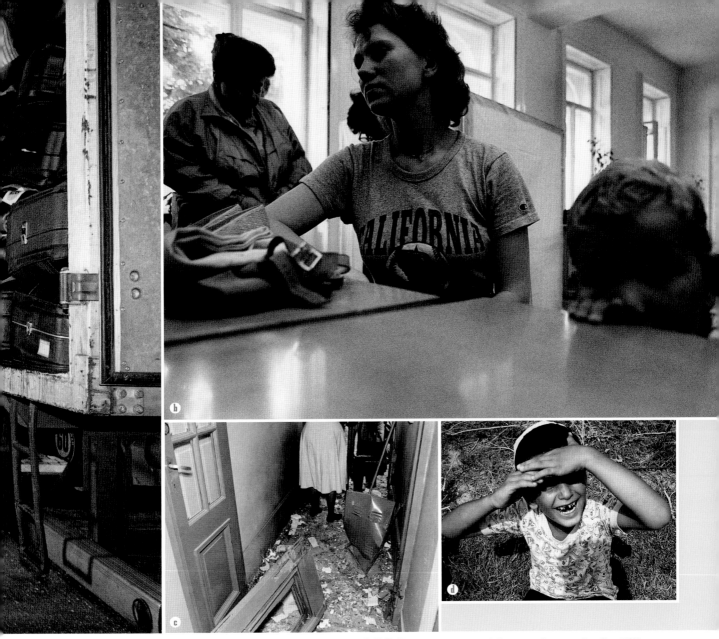

1987 JDC establishes the Latin America Training and Research Center for the Development of Jewish Communal Leadership (LEATID) in Buenos Aires, providing courses and training to prepare high-level professionals for Jewish community leadership positions.

1988 The earliest days of *glasnost* and *perestroika* allow JDC to resume activities in the USSR. JDC begins shipping books to meet the religious and cultural needs of the 2.5 million Soviet Jews.

b Clothing distribution in Vienna, 1989. c After a bomb explosion. Argentina, 1986. d At a transient center in Ladispoli, Italy, 1988.

TERRY WINTERS

When I decided to participate in this project, I had a preconception about the photographs I would find in the JDC archive. It was based on stories I had heard as a kid from older people—I grew up in a neighborhood with a lot of Eastern European emigrants—they told stories about everyday life in the "old world"—jobs people had, things they did. I was curious about the actual places these people came from, the daily experiences and incidental details of their past lives—just what things looked like—landscapes and street scenes. There's something oddly familiar—specific and surreal at the same time—about old photographs. On the one hand there is recognition or belonging, and on the other a sense of discomfort or displacement. I wanted to know where that reverberation could be felt. Looking at the archive images, I suspected it was somewhere between the inexactness of memory and the precision of photography. I wanted my drawings to occupy that gap—to create an emotional space for these feelings—the disjunction between the images I had created out of other people's stories and the hard facts of the photographs.

When I first visited the archive, because of my interest in architecture I looked mostly at photographs of old wooden synagogues. I was taken with the dignity of the buildings, how abstract they were, how they were both independent geometric forms and yet functioned in the community. I related to the formal issues they suggested. They made sense. And I became very excited about making drawings based on these photographs. But it was making so much sense that I couldn't relate to it anymore. In fact, the drawings started to feel more and more forced and I didn't want to end up illustrating some idea.

At that point I felt a need for this project to connect more directly with the ongoing concerns of my work. I was also conscious of not wanting to use the very

real-world subject matter of the archives to add moral or social weight to my images. There is always a certain ambiguity in my work, and I have a commitment to that ambiguity. I don't want to lock specific meanings into the forms that I generate. I want them to have multiple meanings. Anyway, at this time I was working on a series of drawings that in my own mind related to issues of movement and mapping. I began to see these drawings as connected with the archive project. I'd been touched by seeing so much forced emigration—people displaced by circumstances—this seemed to be an overriding condition described in the archives. I started to develop this group of drawings by using simple component parts to build complex structures that suggested migrations—something moving, separating out, forming lines of flight. Territories were being described and occupied. The drawings were abstract diagrams that conveyed the kind of movement I'd been seeing in the JDC photographs.

I'm always trying to take information and data and reassemble it into new configurations, to make new data. These drawings are engineered toward multiplicity—they're aggregates of sensations composed to generate feelings. I want them to be suggestive but free from a one-to-one symbolic reading. Within each drawing there is a sense of movement and a continuity, and then between the drawings there is another sense of movement. The struggle has been to make each one complete in itself, a composite world. At the same time, each one is somehow linked to all of the others. And the meaning of the group also arises from whatever kind of configuration comes with their installation. The drawings are a documentary—a record of my reaction to the archive and the construction of the drawings themselves.

TERRY WINTERS became widely known for his development of a vocabulary of organic forms and painterly, ambiguous spaces in the early 1980s. His work has become increasingly abstract, while still drawing on a broad range of visual material that includes architectural renderings, medical photography, and computer graphics. In his current work he transforms these sources, through the process of painting, into radically complex and paradoxical pictures that combine modernist flatness with perspectival recession, architectural with organic geometry, and an overall lack of hierarchy with a centralized image. At the same time they are intensely atmospheric and seem to pulsate with life and create their own emotional fields.

Terry Winters has had solo exhibitions at numerous museums including the Kunstmuseum, Lucerne; the Tate Gallery, London; the Walker Art Center, Minneapolis; and the Museum of Fine Arts, Boston. In 1991 the Whitney Museum of American Art organized a major retrospective of his work, which traveled to the Museum of Contemporary Art in Los Angeles. A 1998 retrospective at the IVAM Centre Julio Gonzales in Valencia, Spain, will travel to the Whitechapel Art Gallery, London, in February 1999. A retrospective of his prints was organized by the Detroit Institute of Arts for 1998-1999. Born in New York in 1949, he is a graduate of Pratt Institute in Brooklyn and the High School of Art and Design. He is represented by Matthew Marks Gallery, New York, and will have a show there in May 1999.

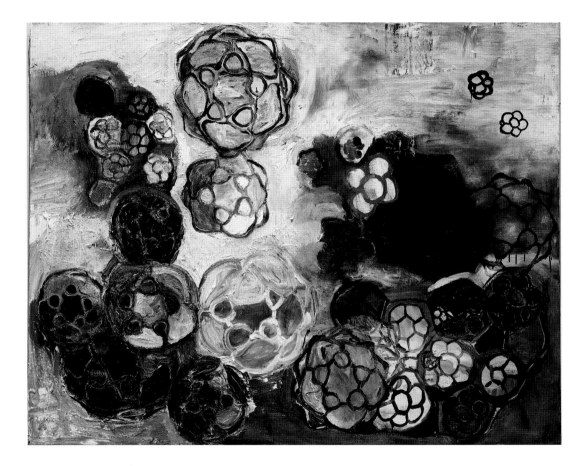

DOUBLE GRAVITY, 1984. Oil on linen. 80 x 104 in.

I'M ALWAYS TRYING TO TAKE INFORMATION AND DATA AND
REASSEMBLE IT INTO NEW CONFIGURATIONS, TO MAKE NEW DATA.
THESE DRAWINGS ARE ENGINEERED TOWARD MULTIPLICITY—
THEY'RE AGGREGATES OF SENSATIONS COMPOSED TO GENERATE
FEELINGS. I WANT THEM TO BE SUGGESTIVE BUT FREE FROM
A ONE-TO-ONE SYMBOLIC READING.

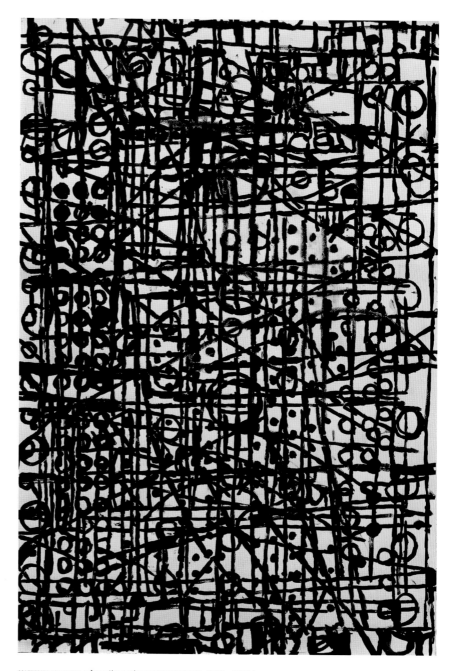

ABSTRACT DIAGRAMS is a set of
nine drawings using a
range of black-and-white
media, from charcoal and
graphite to gouache,
acrylic, and casein. The
work derives from the
specifics of a photographic
record—its historic loca-
tions and narratives—and
explores the archive as a
field of immanence from
which an emotional trajec-
tory is traced.

SCATTERING CONDITIONS, 1 from the series ABSTRACT DIAGRAMS. 30½ x 44¼ in.

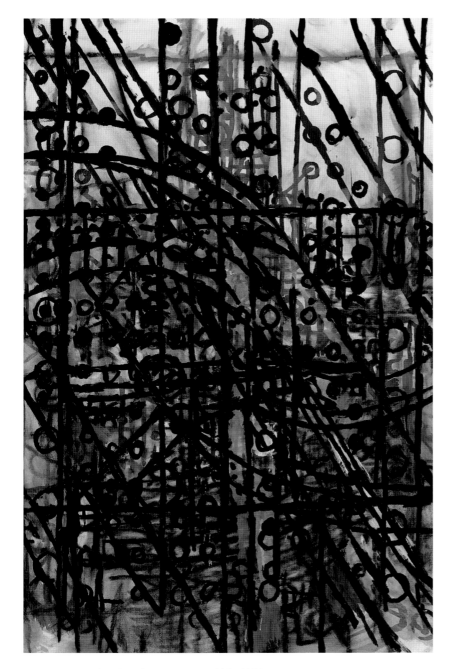

SCATTERING CONDITIONS, 2 from the series ABSTRACT DIAGRAMS. 30½ x 44¼ in.

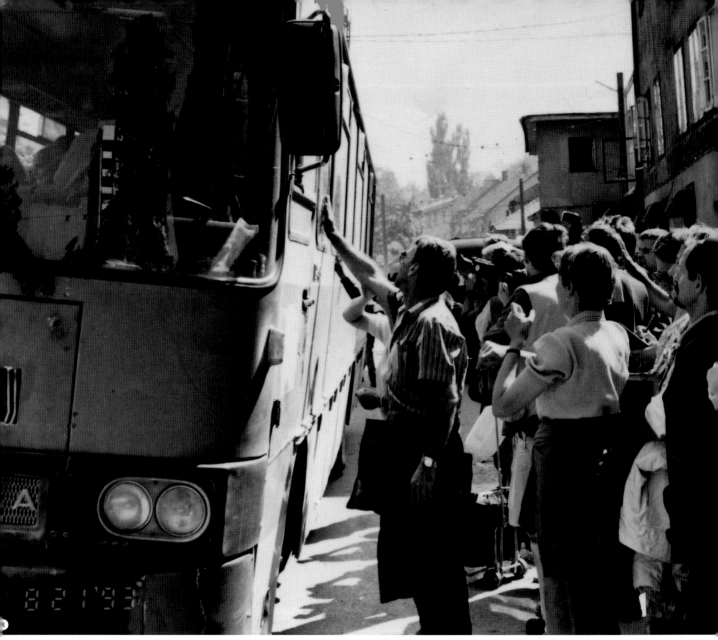

1990
The Ronald S. Lauder Foundation/JDC International Summer Camp for Jewish children is established in Szarvas, Hungary, providing religious and cultural experiences for thousands of young campers from a dozen countries.

Israel reopens its embassy in Addis Ababa, Ethiopia, to provide medical, social, and educational services to 15,000 Jews with hopes of emigrating to Israel. They are airlifted to Israel in Operation Solomon in 1991.

a Bidding farewell to refugees about to be airlifted from Sarajevo, 1993.

1992

JDC distributes 550,000 boxes of food in Moscow and St. Petersburg as part of the U.S. Department of Agriculture's food aid program.

Civil war breaks out in Bosnia-Herzegovina. JDC evacuates 2,200 Bosnian Jews, Muslims, and Christians from Sarajevo and delivers more than 1,500 tons of food, medicine, and clothing to refugees in Serbia, Croatia, Slovenia, and Macedonia.

b After a missile attack during the Gulf War. Ramat Gan, Israel, 1991. c Sarajevo airlift, 1992.

JDC launches a comprehensive nonsectarian eye treatment project in Zimbabwe. In two years more than 11,000 patients are treated and 600 operations are performed.

1994 Civil war breaks out in Rwanda. JDC forms a Jewish coalition of over thirty organizations to provide aid, especially medical assistance, to Rwandan refugees.

a Making matzoh in preparation for the holidays. St. Petersburg, Russia, 1992. b Rwanda, 1995. c Mentally handicapped residents of the Or Institute in Netanya help pick Jaffa oranges for Israeli farmers, who lack the necessary manpower. d Hebrew alphabet cards distributed to children by the JDC. Former Soviet Union, 1993. e Train from Vienna carrying transmigrants to Italy. Ladispoli, 1990. f Thailand, 1990. g Kurdish refugee campsite in Silopi, Turkey, 1991. h An exercise class at the Rehovot Day Care Center for the

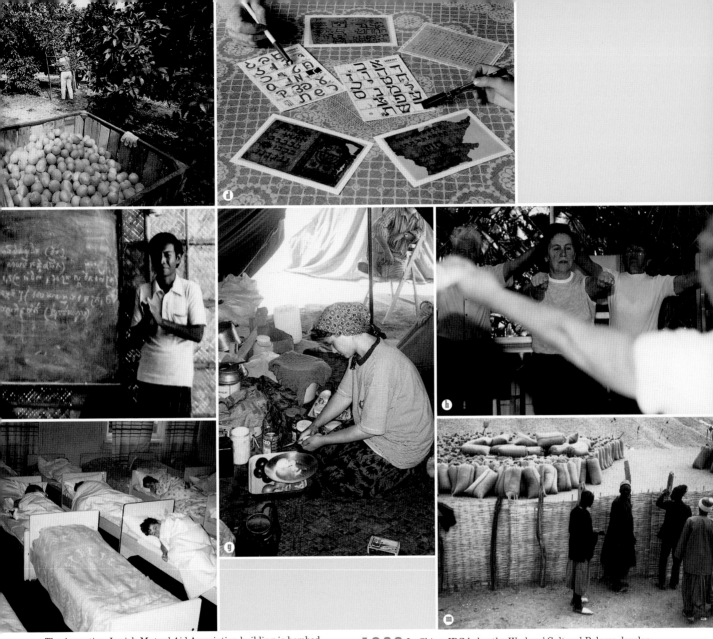

The Argentine Jewish Mutual Aid Association building is bombed, leaving 87 people dead, 200 wounded, and damaging the property of 900 families. JDC staff work with the local community to provide immediate assistance.

1998 In China JDC helps the Workers' Cultural Palaces develop community-based programs for the elderly.

Elderly. Israel, 1992. **i** Bulgaria, 1992. **j** Thailand, 1990. **k** March of the Living. Poland, 1994. Jewish students visit concentration camps in Poland to keep from forgetting the past. **l** Simcha kindergarten in Kiev, former Soviet Union, 1994. **m** Sudan, 1990s.

Evacuation from Sarajevo, 1992.